Chris Hart

Drawing
Wizards, Witches
and Warlocks

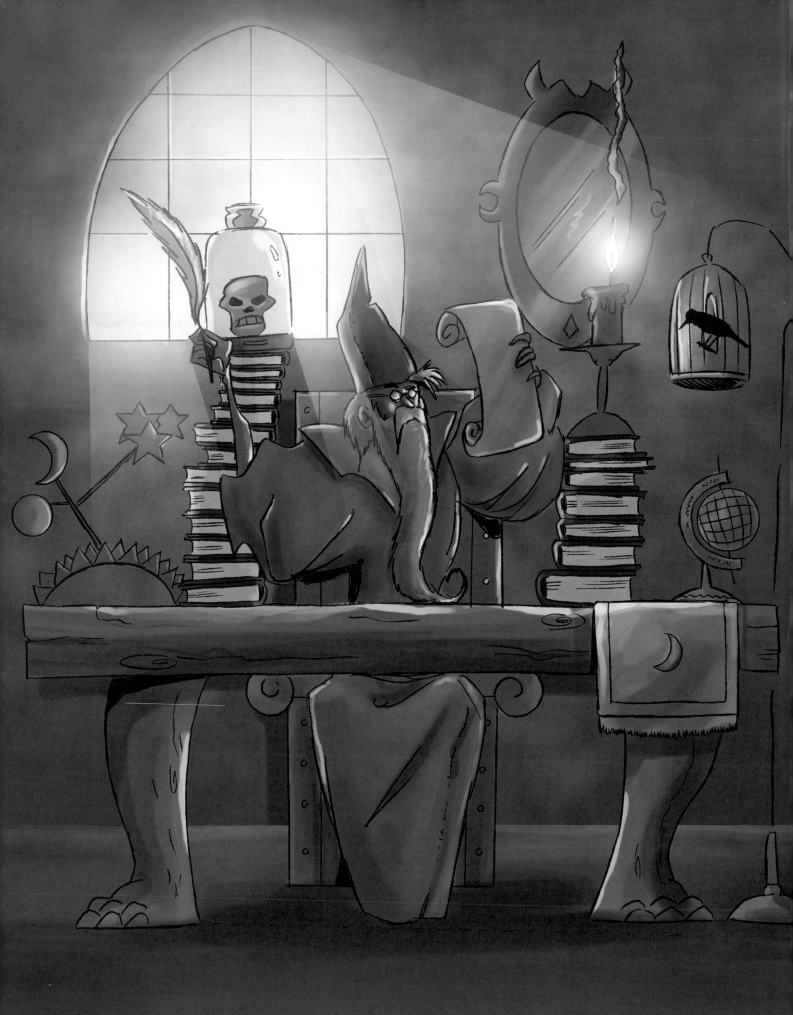

Chris Hart

Drawing Wizards, Witches and Warlocks

Chris Hart Books

**An imprint of
Sixth&Spring Books
233 Spring Street
New York, New York 10013**

Editorial Director
ELAINE SILVERSTEIN

Book Division Manager
WENDY WILLIAMS

Senior Editor
MICHELLE BREDESON

Art Director
DIANE LAMPHRON

Associate Art Director
SHEENA T. PAUL

Copy Editor
KRISTINA SIGLER

Color
ROMULO FAJARDO, JR. MAE HAO
MIKE BARTOLO RAYANN BERNARDO

Vice President, Publisher
TRISHA MALCOLM

Production Manager
DAVID JOINNIDES

Creative Director
JOE VIOR

President
ART JOINNIDES

Library of Congress Control Number: 2008925013

ISBN-13: 978-1-933027-68-5
ISBN-10: 1-933027-68-1

Manufactured in China

1 3 5 7 9 10 8 6 4 2

First Edition

chrishartbooks.com

Contents

Welcome
to a world of
mystery
and magic!

This book is your passport to a land of magical characters and awesome creatures. If you are really interested in learning how to draw the inhabitants of the fantasy realm, rather than simply looking at examples, this is the book you've been waiting for.

Magical fantasy is an enduringly popular genre that takes its inspiration from myths, fairy tales and folklore. The most popular magical characters lie within the covers of this book: amazing wizards, evil witches, devilishly handsome warlocks, fearsome dragons, and many other mesmerizing characters and mythical beasts. You'll learn how to draw their strange forms, costumes, expressions and action poses, as well as the magical effects that make them so famous.

Each chapter focuses on one group of fantasy characters, such as warlocks, while exploring the art techniques necessary to capture the look, mood and personality of the characters. Within each chapter you'll find many characters of varying ages, styles and personalities.

There is a multitude of step-by-step demonstrations, supplemented with tons of visual hints, provided within these pages. Each step in a given demonstration adds new elements to a drawing. These new parts are highlighted in blue pencil so you can easily distinguish them from the rest of the drawing. The encouraging text will guide you so that you achieve the results you desire—faster than you ever expected. This book is specifically written and designed to show you how to draw your favorite fantasy characters and perhaps even create some of your own!

As the artist, you are the sorcerer in charge. The pencil is your wand, the paper your cauldron. And this book contains the spells that will enable you to create characters and creatures from worlds beyond.

Fantasy Facial Features

Before we look in depth at each of the types of beings that inhabit the magical realm, let's briefly compare their features. The characters and creatures in this book are not of the same bloodlines, or sometimes even species, and their differences should be reflected in their very features. We'll begin with the eyes, for nothing carves out an identity as clearly as a well-drawn eye.

WEIRD EYES

There are many characteristics and techniques to choose from when designing fantastical eyes. Here is a menu of choices from which you can select:

- Vary the size and shape of the pupils
- Fill in the pupils or leave them blank
- Place the eyes close together or far apart
- Decide whether or not to show eyelids
- Vary the shape of the eyebrows
- Vary the thickness of the eyebrows
- Add eyelashes
- Indicate tear ducts

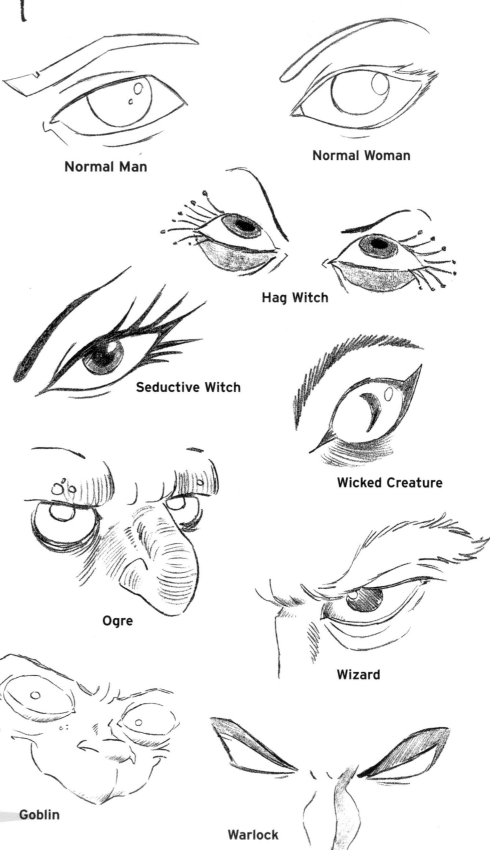

Normal Man

Normal Woman

Hag Witch

Seductive Witch

Wicked Creature

Ogre

Wizard

Goblin

Warlock

8

STRANGE NOSES

Odd as it may seem, we often associate a character's nose with his or her personality and even intelligence. Witches usually have crooked noses, a pugnacious nose goes with a brutish character, and so on.

Where you place the nose determines the look of the entire profile. Place the nose high on the head, and the character will end up with a tiny cranium and a big jaw area—sure signs of a brute. Placing the nose low on the head will give the character a big forehead and a tiny chin and make him look weak. Place the nose in the center of the face, and the character will appear to be of normal, or even high, intelligence.

In the world of fantasy, noses vary tremendously in size, shape and placement.

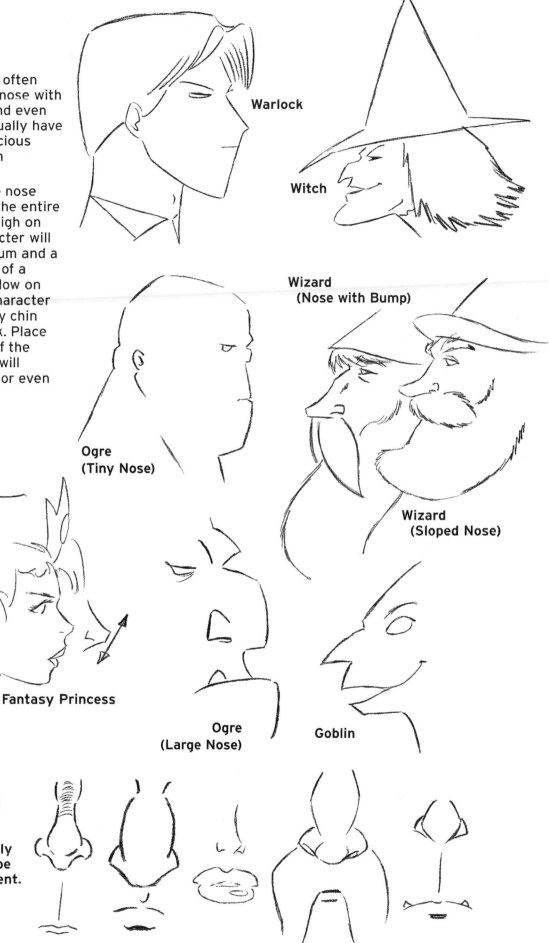

Warlock

Witch

Wizard
(Nose with Bump)

Ogre
(Tiny Nose)

Wizard
(Sloped Nose)

Fantasy Princess

Ogre
(Large Nose)

Goblin

9

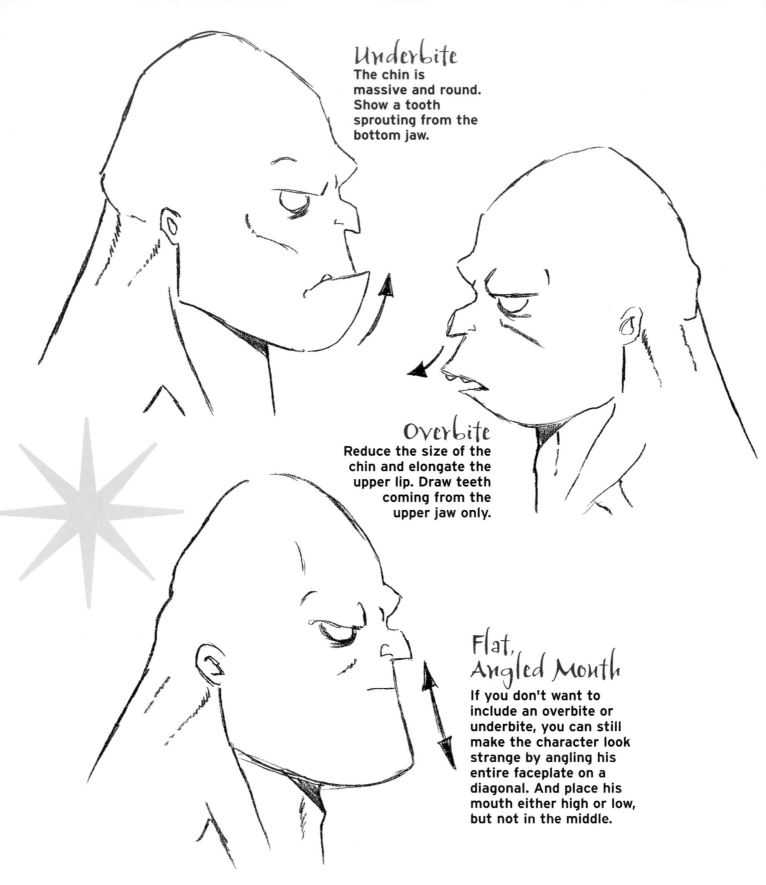

Underbite
The chin is massive and round. Show a tooth sprouting from the bottom jaw.

Overbite
Reduce the size of the chin and elongate the upper lip. Draw teeth coming from the upper jaw only.

Flat, Angled Mouth
If you don't want to include an overbite or underbite, you can still make the character look strange by angling his entire faceplate on a diagonal. And place his mouth either high or low, but not in the middle.

OVERBITES & UNDERBITES
Manipulating the upper and lower jaws is the simplest way to create an otherworldly look for your semi-human magical characters. Bewitched creatures like ogres, cyclopes and even trolls take on a strange and mysterious look when given a significant overbite or underbite.

HEAR YE! HEAR YE!

There are no hard-and-fast rules for drawing fantasy ears, but there are conventions that work well. One of them is this: The smaller the creature, the larger the ears, and vice versa. Ogres generally have small, slightly pointed ears. Smaller creatures such as trolls and goblins are often drawn with extra-long ears.

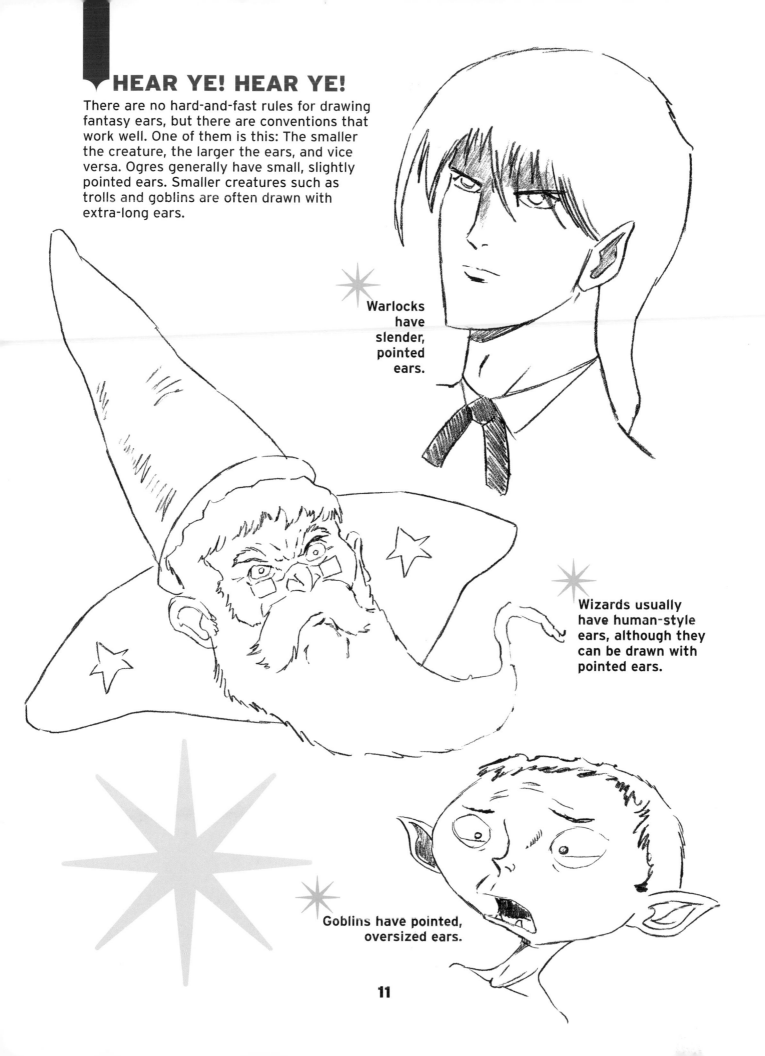

Warlocks have slender, pointed ears.

Wizards usually have human-style ears, although they can be drawn with pointed ears.

Goblins have pointed, oversized ears.

11

Wizards
Masters of Sorcery

The first stop on our journey through the fantasy realm will be to learn how to draw wizards. These popular characters appear in fantasy illustrations, books, comics and movies. In this chapter we'll feature a few of them and learn the basics of drawing any wizard.

So let us wind our way through the woods to the castle tower, domain of the master of all conjuring.

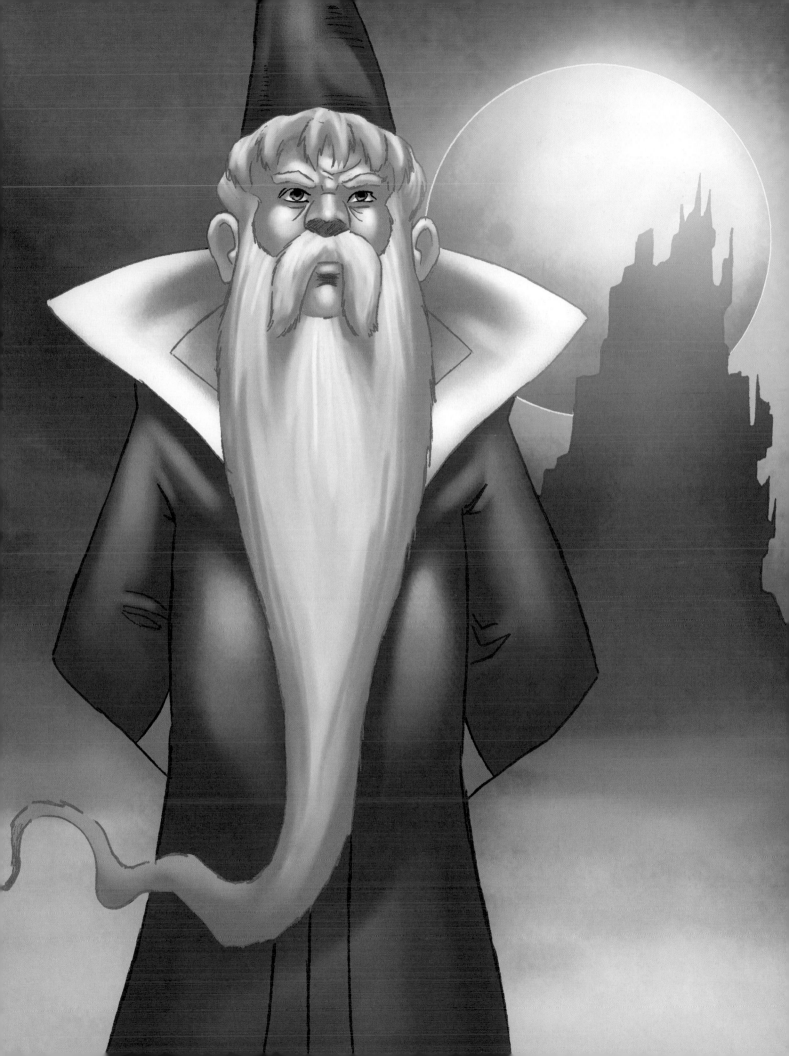

All-Knowing Wizard

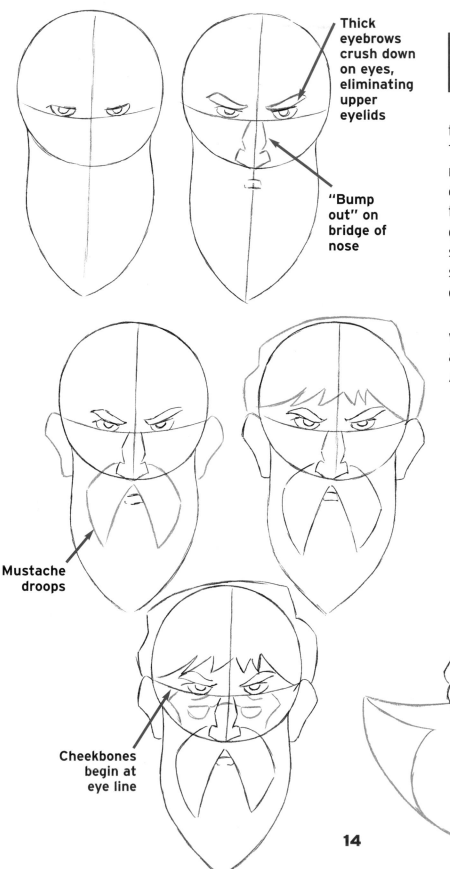

Thick eyebrows crush down on eyes, eliminating upper eyelids

"Bump out" on bridge of nose

Mustache droops

Cheekbones begin at eye line

izards are challenging to draw because the bones of their faces are so prominent. Their mustaches also must be more expressive than other characters' because they mask the mouth. But if you start gradually and take it step by step, you'll find the wizard surprisingly easy to draw. Let's dig in and give it a try.

We'll begin with the classic wizard, the granddaddy of all medieval magicians: the All-Knowing Wizard.

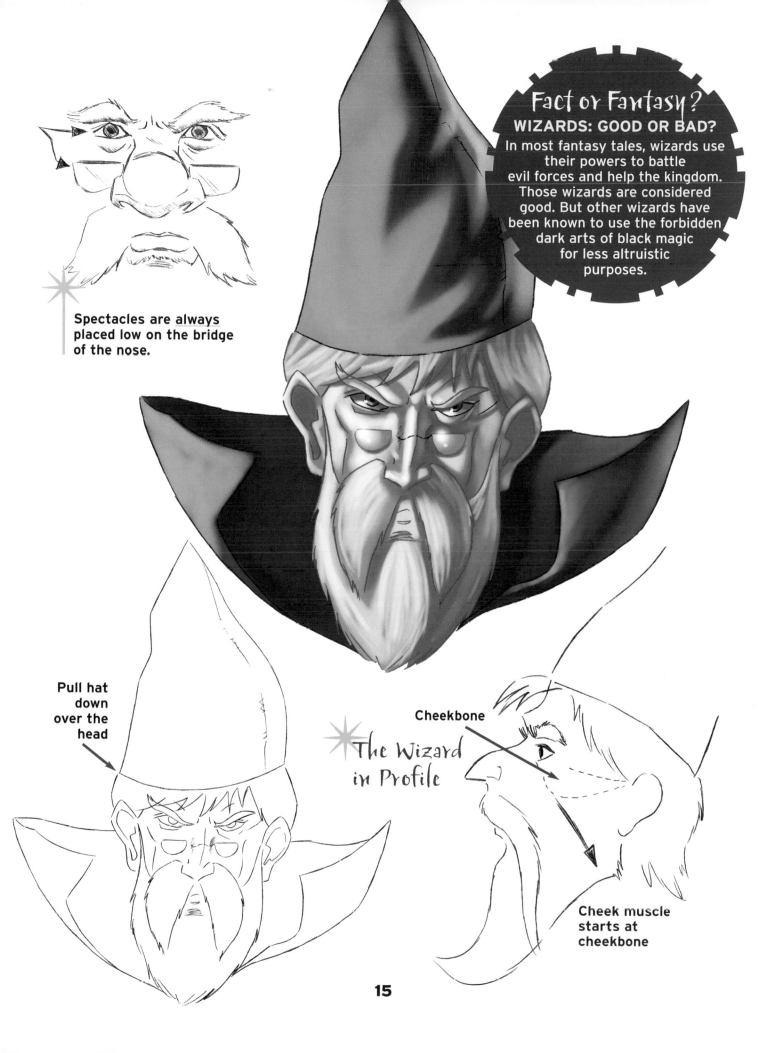

Spectacles are **always** placed low on the bridge of the nose.

Fact or Fantasy?
WIZARDS: GOOD OR BAD?
In most fantasy tales, wizards use their powers to battle evil forces and help the kingdom. Those wizards are considered good. But other wizards have been known to use the forbidden dark arts of black magic for less altruistic purposes.

Pull hat down over the head

The Wizard in Profile

Cheekbone

Cheek muscle starts at cheekbone

15

Curious Wizard

The tricky part of drawing a three-quarter view like this one is getting the eye on the far side of the head to look right: It appears small due to perspective. First draw the bridge of the nose, which all but obscures the far eye. That will make the eye seem less prominent. And bump out the forehead and cheekbones on the far side of the head as well.

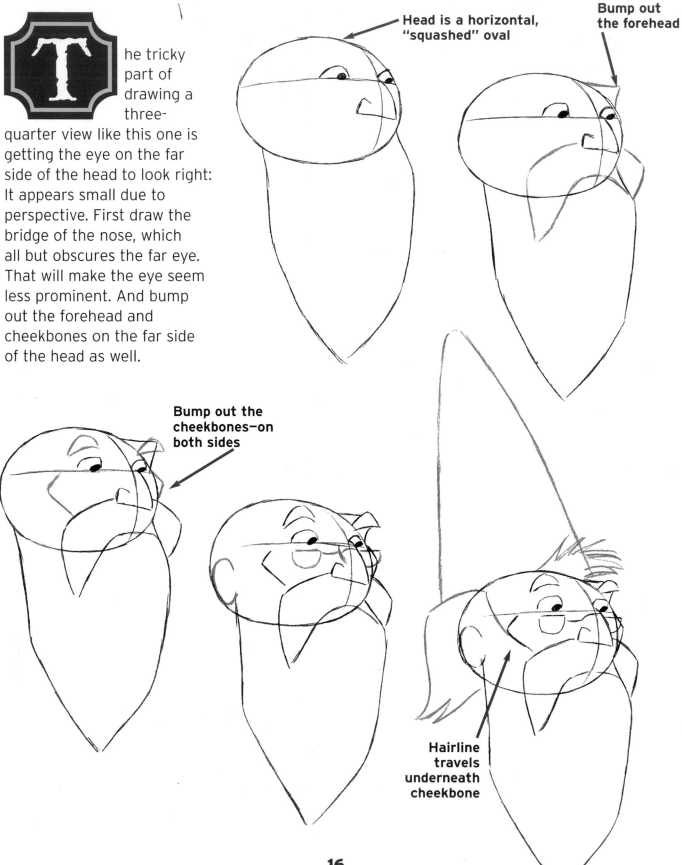

Head is a horizontal, "squashed" oval

Bump out the forehead

Bump out the cheekbones—on both sides

Hairline travels underneath cheekbone

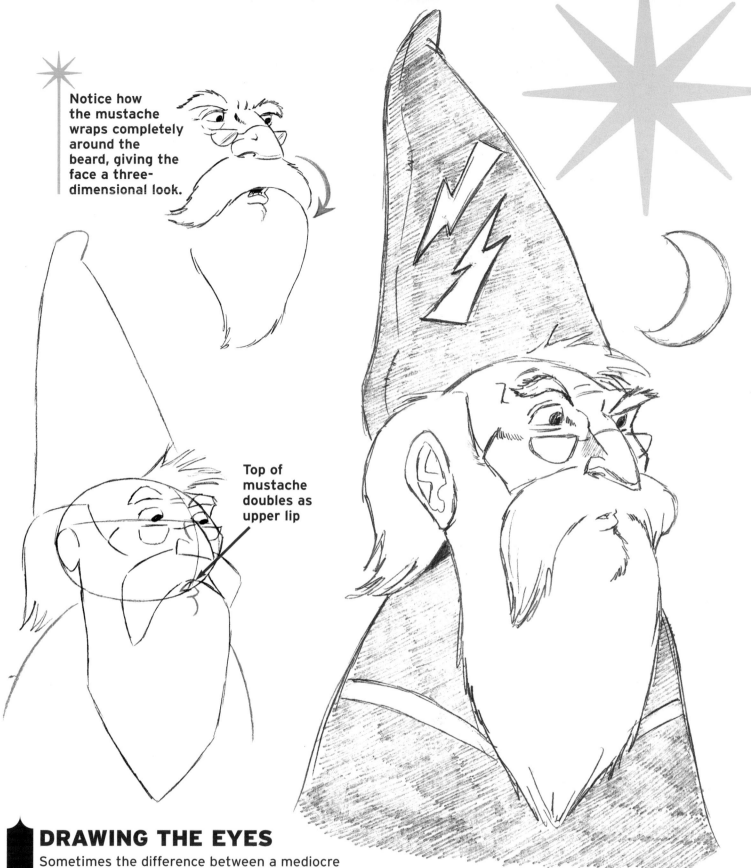

Notice how the mustache wraps completely around the beard, giving the face a three-dimensional look.

Top of mustache doubles as upper lip

DRAWING THE EYES

Sometimes the difference between a mediocre drawing and a good one is a small one. It's often a matter of how you draw the eyes. Is the character really "seeing" something, or just staring into space? Don't let your character's eyes wander. Firmly place the pupils so that your character appears to be looking intently at something, especially when you draw a curious character like this wizard. I like to place the pupils in the corners of the eyes, as I believe it anchors them comfortably.

Wizard & Friend

For this side view, or profile, we'll start with a more unusual head shape. We also play with the beard, letting it take on a life of its own as it curls up and to a point.

Note the wizard's hat. This look, which is seen only in fantasy illustrations, not usually in medieval stories featuring knights, often signifies a wizard with spectacular powers.

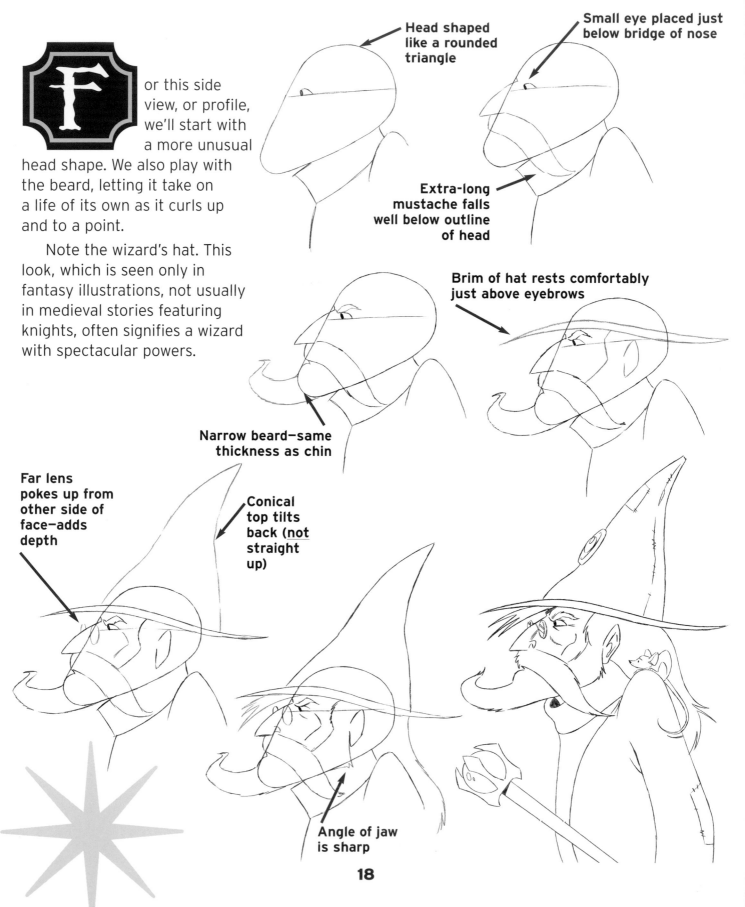

Head shaped like a rounded triangle

Small eye placed just below bridge of nose

Extra-long mustache falls well below outline of head

Brim of hat rests comfortably just above eyebrows

Narrow beard—same thickness as chin

Far lens pokes up from other side of face—adds depth

Conical top tilts back (<u>not</u> straight up)

Angle of jaw is sharp

✳ Like all wizards, this sorcerer is attuned to nature, and he has a little helper to accompany him on his journey.

THE LOOSE SKETCH

Here's my initial sketch before I traced over it to create the final version. It's good practice to sketch loosely and allow yourself to make mistakes. Some beginners think a successful drawing is one in which you don't erase, but nothing could be further from the truth! Sketching and doing a "clean-up" drawing are two different stages, and should be attacked with two different mindsets. The first is loose, creative, and unrestricted. The second is much more meticulous. You'll find a few of these loose sketches throughout this book. I hope they will inspire you to do some of your own.

The Wizard's Wardrobe

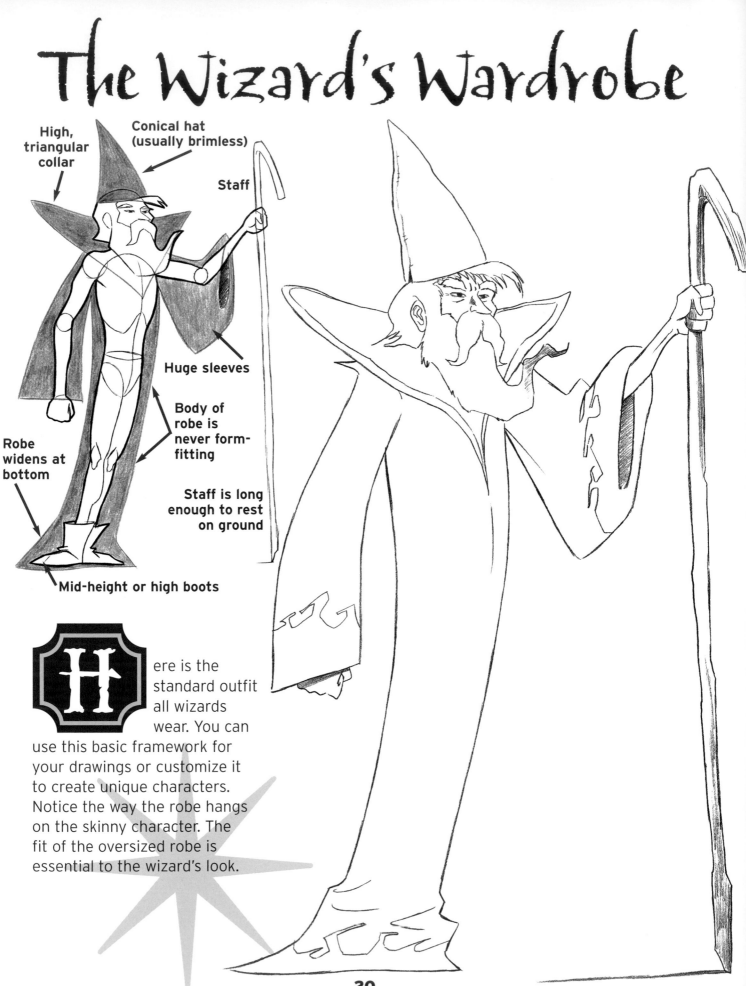

High, triangular collar

Conical hat (usually brimless)

Staff

Huge sleeves

Body of robe is never form-fitting

Robe widens at bottom

Staff is long enough to rest on ground

Mid-height or high boots

Here is the standard outfit all wizards wear. You can use this basic framework for your drawings or customize it to create unique characters. Notice the way the robe hangs on the skinny character. The fit of the oversized robe is essential to the wizard's look.

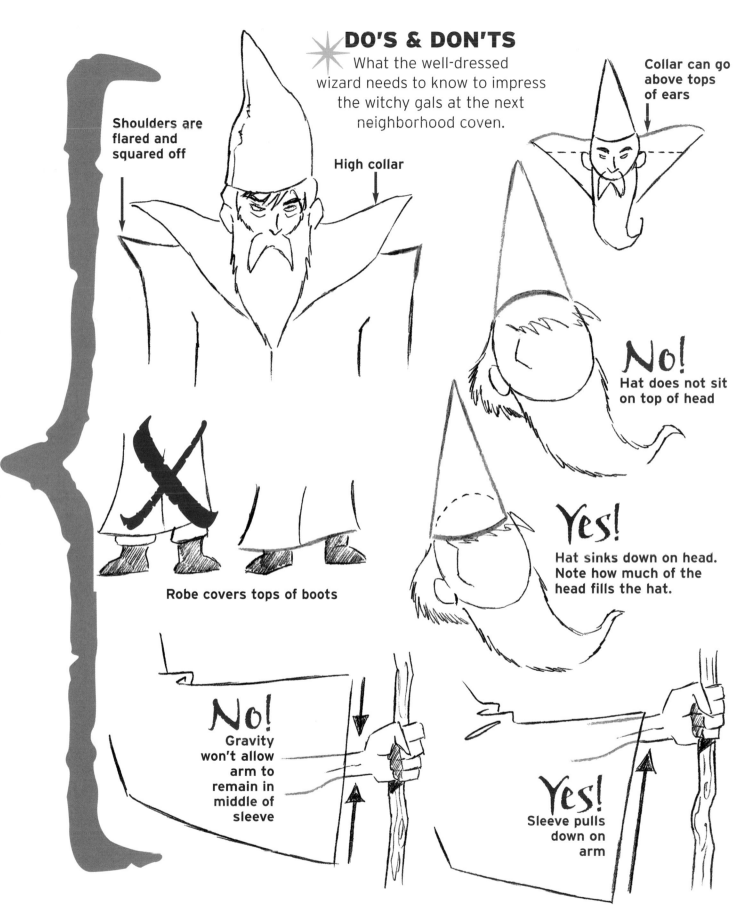

DO'S & DON'TS

What the well-dressed wizard needs to know to impress the witchy gals at the next neighborhood coven.

Shoulders are flared and squared off

High collar

Collar can go above tops of ears

Robe covers tops of boots

No! Hat does not sit on top of head

Yes! Hat sinks down on head. Note how much of the head fills the hat.

No! Gravity won't allow arm to remain in middle of sleeve

Yes! Sleeve pulls down on arm

Wizarding Props

The wizard is an alchemist, experimenting with his potions and charms in the forbidden realm of nature's secrets. What he creates is powerful but not always exactly what he had foreseen.

These props are typical of a wizard's overcluttered tower. Use them to enhance the atmosphere of your scenes. Sometimes a single prop is enough to suggest a story: A picture of a wizard gazing into a crystal ball stirs the imagination more than one of a wizard simply standing, no matter how well drawn the image.

Candle
Always half melted

Enchanted Bird
Converses with wizard

Standing cage

Crystal Ball
Has a craggy wooden base

Skull in Glass Case
Easy to transport!

Great Book of Potions
Kept under lock and key

Toad (Not a Frog)
The bigger, fatter and uglier the better!

Writing Instruments
Make them flamboyant

The Wizard at Work

The wizard works alone, possessed by his labors, oblivious to his clutter, like a medieval mad scientist. He is often shown seated behind an imposing wooden desk, surrounded by stacks of thick books, which symbolize his erudition.

Cranky Wizard

Oval skull shape

Large, rounded nose

Make eyebrows uneven— one up, the other down

Wide cheekbones

Add plenty of length to beard

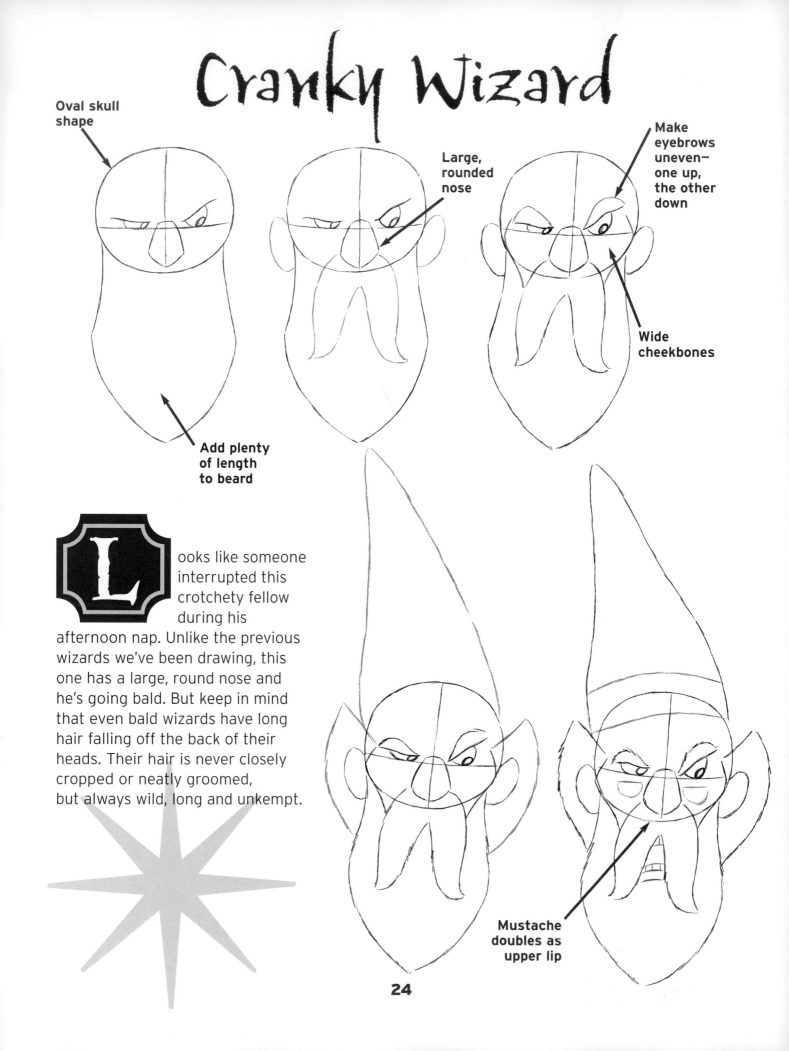

Looks like someone interrupted this crotchety fellow during his afternoon nap. Unlike the previous wizards we've been drawing, this one has a large, round nose and he's going bald. But keep in mind that even bald wizards have long hair falling off the back of their heads. Their hair is never closely cropped or neatly groomed, but always wild, long and unkempt.

Mustache doubles as upper lip

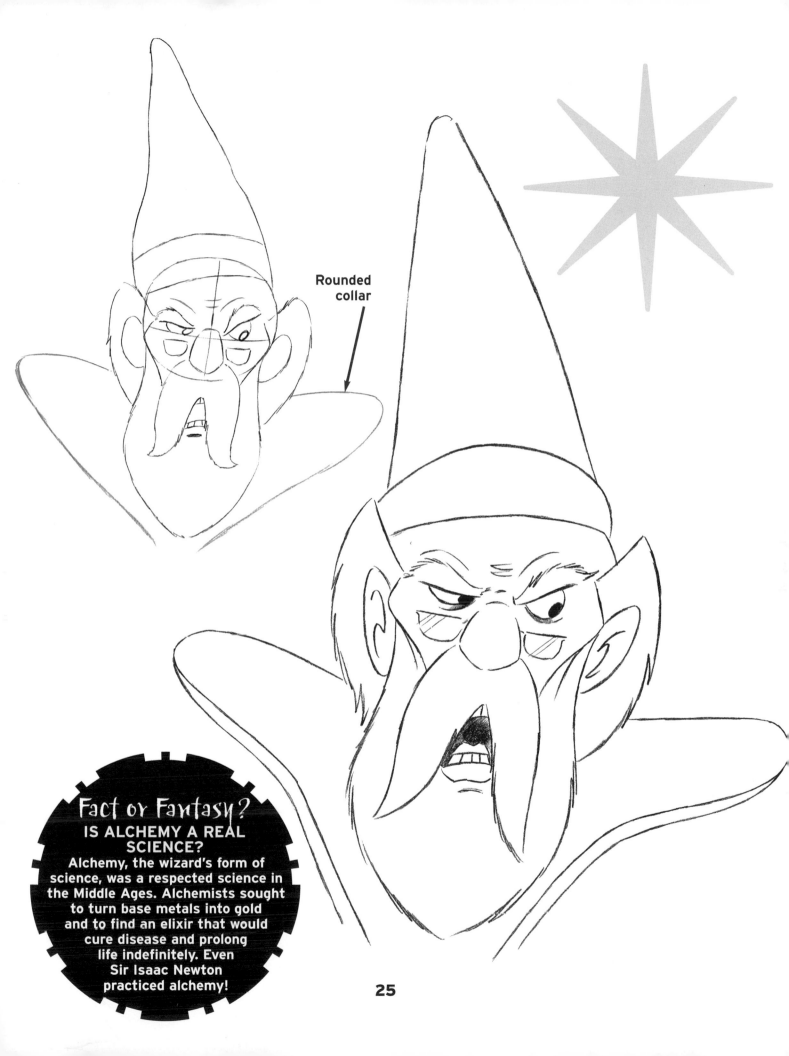

Rounded collar

Fact or Fantasy?
IS ALCHEMY A REAL SCIENCE?
Alchemy, the wizard's form of science, was a respected science in the Middle Ages. Alchemists sought to turn base metals into gold and to find an elixir that would cure disease and prolong life indefinitely. Even Sir Isaac Newton practiced alchemy!

25

An Inquisitive Fellow

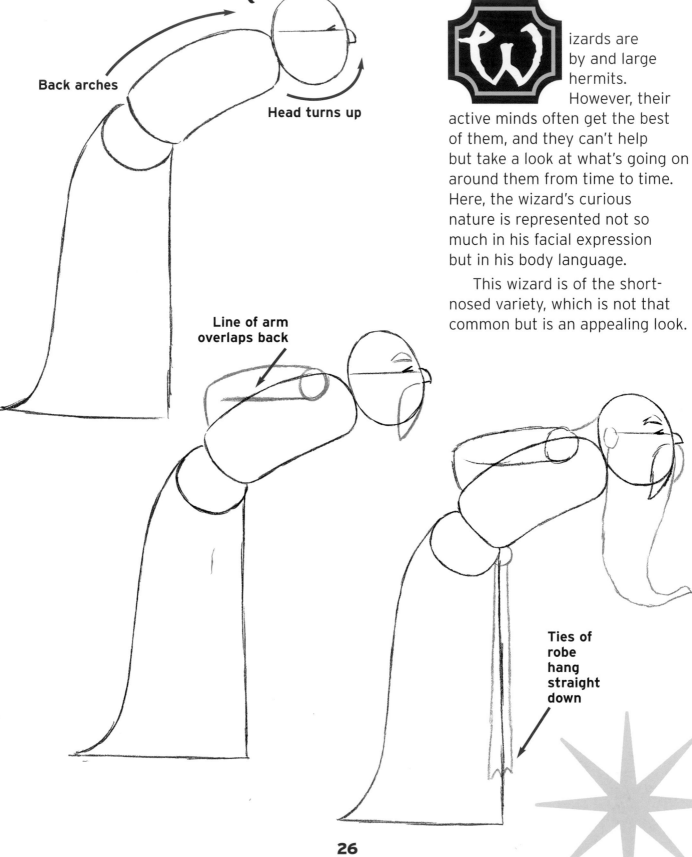

Back arches

Head turns up

Line of arm overlaps back

Ties of robe hang straight down

izards are by and large hermits. However, their active minds often get the best of them, and they can't help but take a look at what's going on around them from time to time. Here, the wizard's curious nature is represented not so much in his facial expression but in his body language.

This wizard is of the short-nosed variety, which is not that common but is an appealing look.

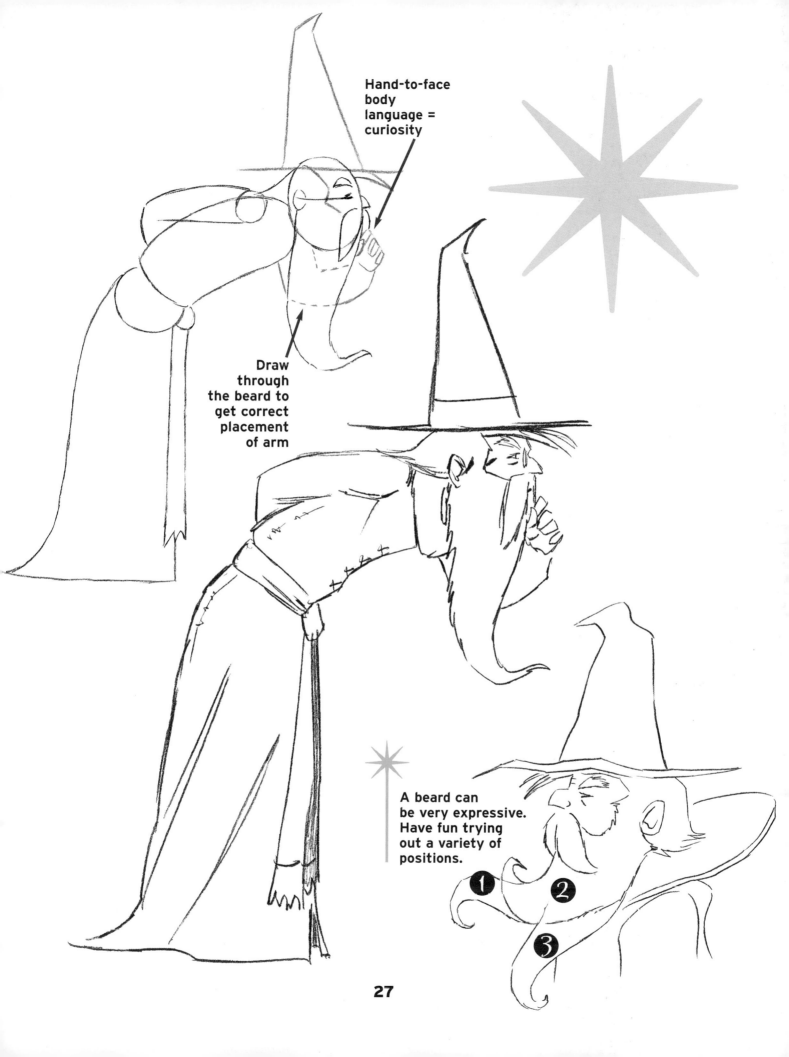

Hand-to-face
body
language =
curiosity

Draw
through
the beard to
get correct
placement
of arm

A beard can
be very expressive.
Have fun trying
out a variety of
positions.

① ② ③

27

Backgounds: KEEP THEM SIMPLE
An abstract suggestion of a background is often more effective than a tightly rendered one, which can compete with the figure in the foreground. Note how the large, disk-shaped moon overlaps and, therefore, ties together the wizard and the castle on the hill into a single image.

Super-Long Beards

An extra-long beard makes a big impression. It also lends an element of mysticism to the character, more so than a normal-length beard. The longer the beard, the wiser the wizard. The beard should trail off into little squiggles at the end.

See his penetrating, pensive look? We get that effect by showing him looking up slightly, a good angle for someone deep in thought.

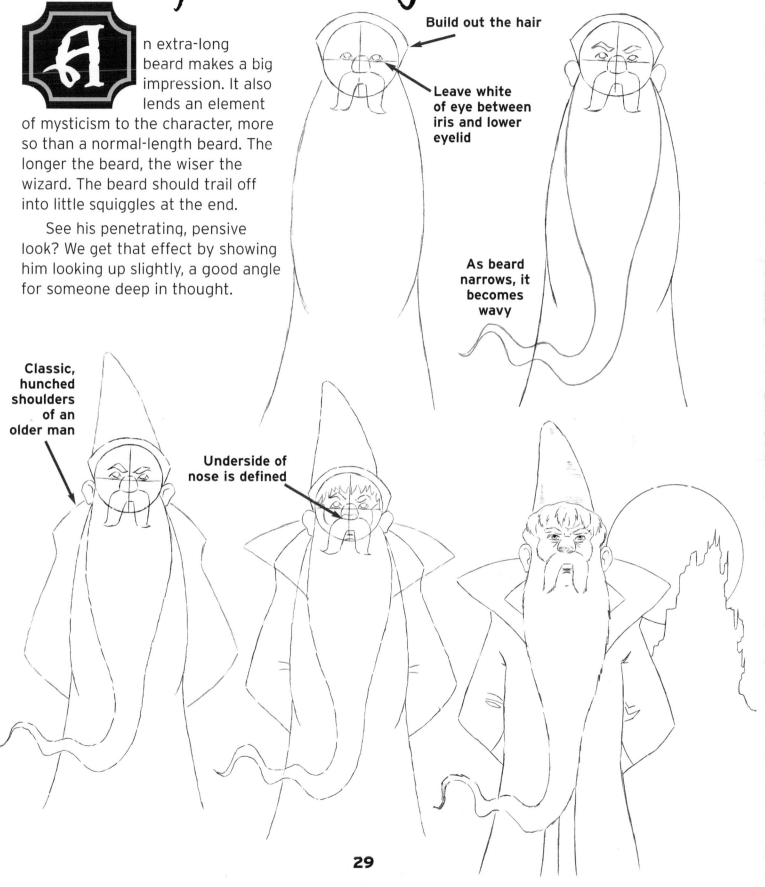

Build out the hair

Leave white of eye between iris and lower eyelid

As beard narrows, it becomes wavy

Classic, hunched shoulders of an older man

Underside of nose is defined

This unhappy spirit has been summoned by the wizard and must do his bidding.

The Wizard's Powers

Wide stance, for stability and balance

Arms rise above head

Sleeves creep down arms, due to gravity

 ery little in the fantasy realm is more dramatic than a wizard who has let loose his fury. When creating powerful scenes featuring the wizard's powers, don't focus all your efforts on drawing the fun special effects. They're icing on the cake. The foundation that makes the drawing work is still the pose. Without a dynamic pose, any magical special effect would fall flat.

SUMMONING SPIRITS

The wizard works hard to create magic, and this exertion must be conveyed in the drawing. The entire body moves with the thrust of the pose, which in this case means that the arms rise well above the head.

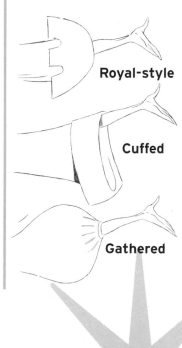

Other Styles of Robe Sleeves

Royal-style

Cuffed

Gathered

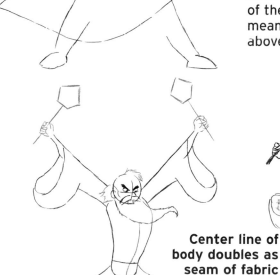

Pentagon-shaped jewels

Center line of body doubles as seam of fabric

Robe blown by the forces of nature

Keep spirit's face vague, so it doesn't compete with wizard's

31

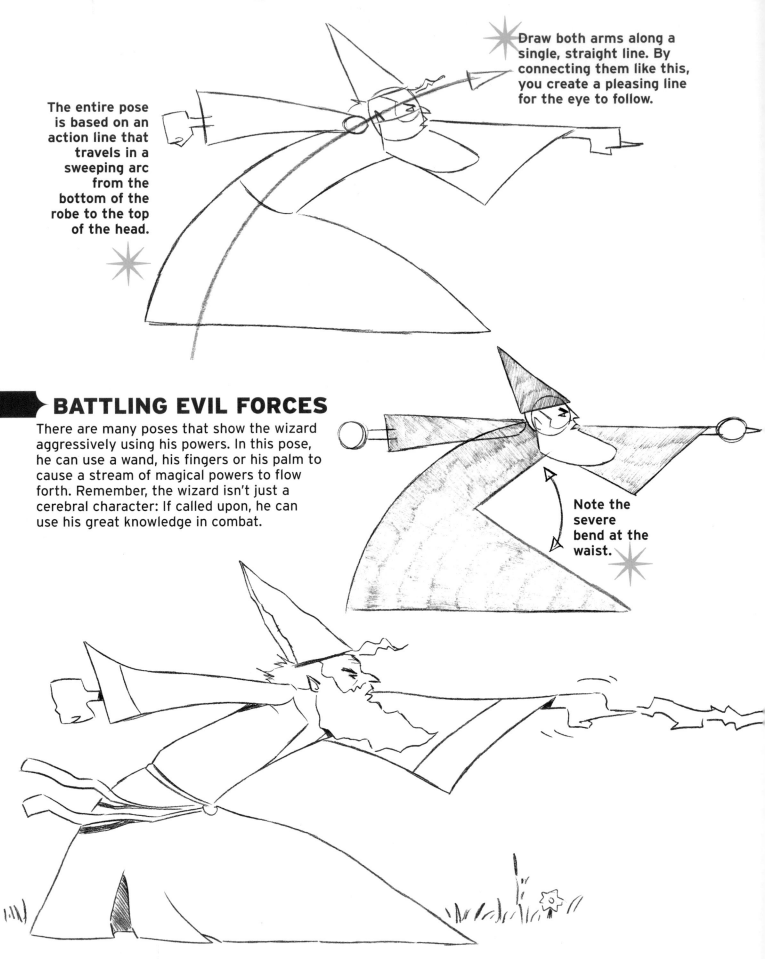

The entire pose is based on an action line that travels in a sweeping arc from the bottom of the robe to the top of the head.

Draw both arms along a single, straight line. By connecting them like this, you create a pleasing line for the eye to follow.

BATTLING EVIL FORCES

There are many poses that show the wizard aggressively using his powers. In this pose, he can use a wand, his fingers or his palm to cause a stream of magical powers to flow forth. Remember, the wizard isn't just a cerebral character: If called upon, he can use his great knowledge in combat.

Note the severe bend at the waist.

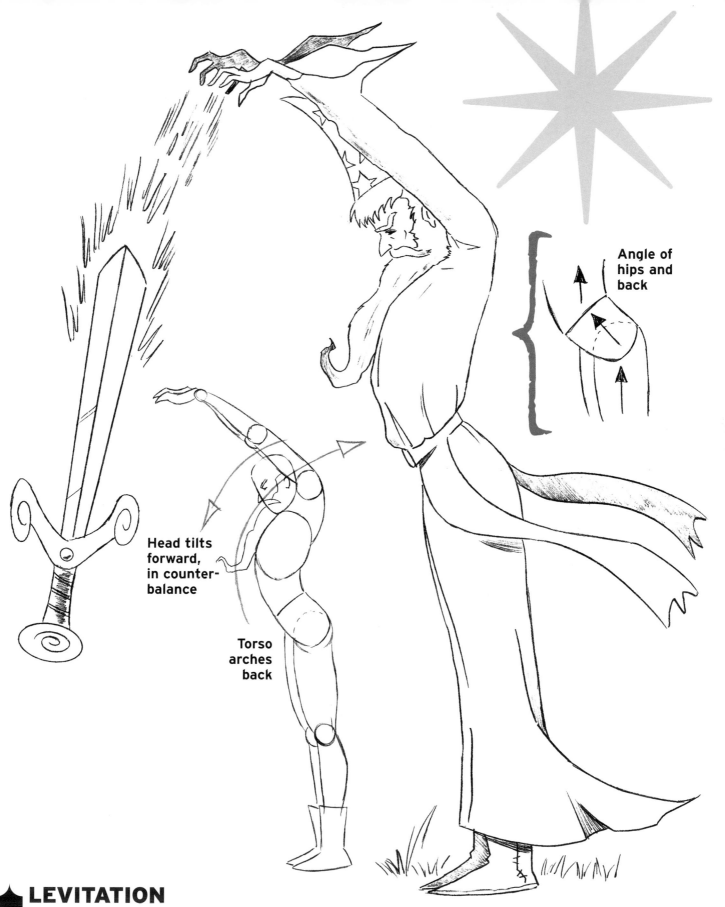

Angle of hips and back

Head tilts forward, in counter-balance

Torso arches back

LEVITATION

A third pose in which the wizard invokes his powers is levitation. Levitation is often a secondary effect that occurs while the wizard is imbuing an object with special powers. Here, in profile, the wizard's legs are side by side, as are his arms. The body is stretched to its tallest point. And note the counterbalance: As his torso arches back, his head arches forward.

Forest Wizard

You often see this wizard approach out of the mists of the forest, carrying a craggy branch as a staff. He is a particularly mysterious character. His robes are basic, never flamboyant, and he wears a hat with a brim. Note the composition: We position him stepping over the rocks, with one foot in front and one foot hidden behind them. This creates a feeling of depth and suggests that the wizard has traveled some distance.

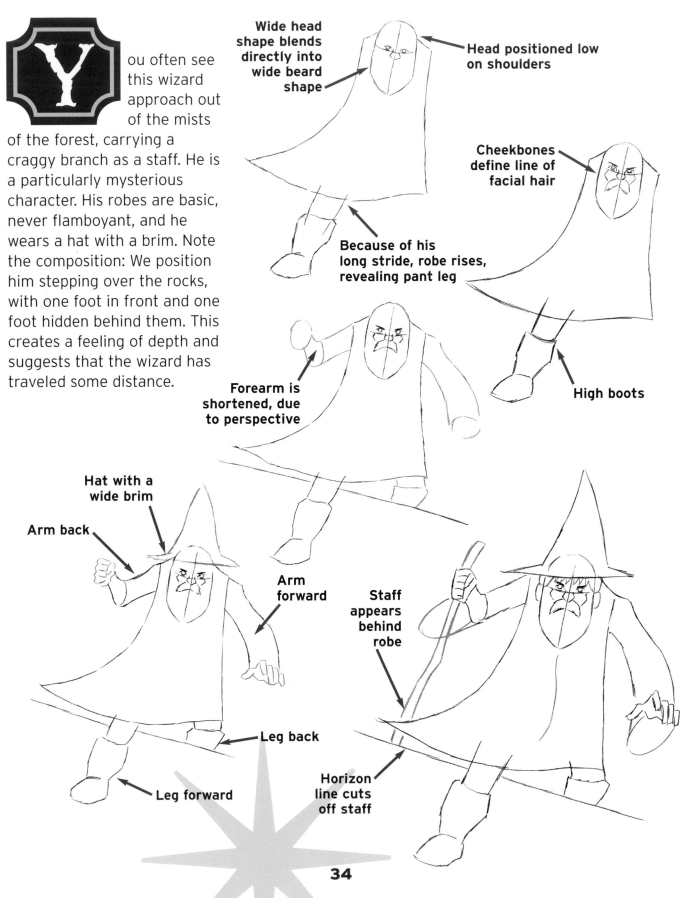

Wide head shape blends directly into wide beard shape

Head positioned low on shoulders

Cheekbones define line of facial hair

Because of his long stride, robe rises, revealing pant leg

High boots

Forearm is shortened, due to perspective

Hat with a wide brim

Arm back

Arm forward

Staff appears behind robe

Leg back

Leg forward

Horizon line cuts off staff

34

WIZARD IN MOTION

Note the classic walk position of the arms and legs. The arm and leg on the same side of the body swing in opposite directions. For example, his right foot is forward, which means his right arm must be back. You need to indicate this, even in the front view.

Learned Wizard

n an age when human-kind was still immersed in darkness, the wizard was an intellectual. He could read and write—no small feat during the Dark Ages. He was also a master at games of skill, such as chess. Here he reads from a scroll, which is a more versatile prop than a book.

A good addition to the robe is a hood, which flops over the shoulders and down the back. When the sorcerer wants to travel unrecognized, he pulls the hood up over his head, bathing his face in shadow.

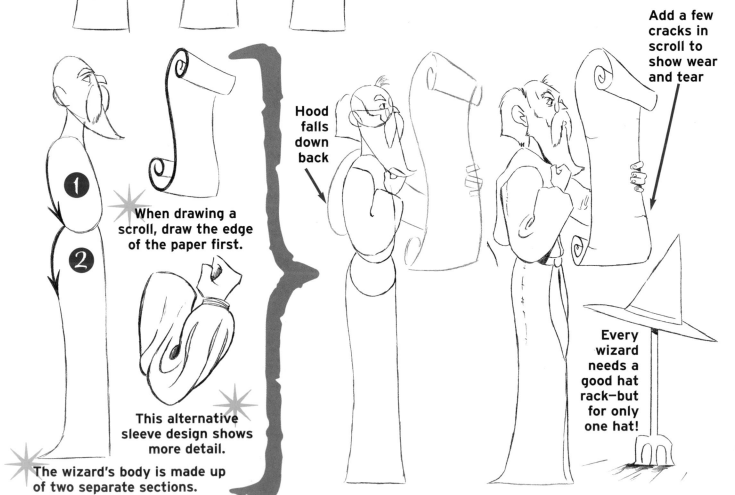

Add a few cracks in scroll to show wear and tear

When drawing a scroll, draw the edge of the paper first.

This alternative sleeve design shows more detail.

The wizard's body is made up of two separate sections.

Hood falls down back

Every wizard needs a good hat rack—but for only one hat!

"Hmm... Eye of newt, hair of dog, dragon's tooth and griffin's claw... Wait for the full moon to glow, stir it well and there you go."

Tall Wizard

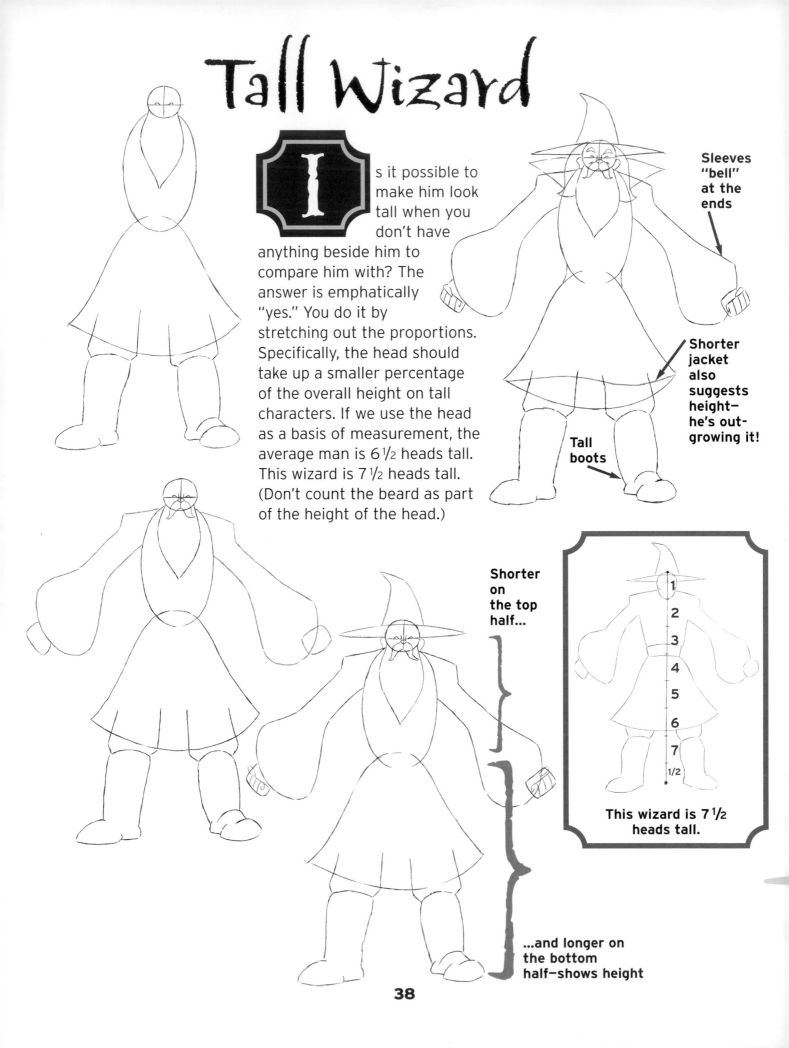

Is it possible to make him look tall when you don't have anything beside him to compare him with? The answer is emphatically "yes." You do it by stretching out the proportions. Specifically, the head should take up a smaller percentage of the overall height on tall characters. If we use the head as a basis of measurement, the average man is 6½ heads tall. This wizard is 7½ heads tall. (Don't count the beard as part of the height of the head.)

Sleeves "bell" at the ends

Shorter jacket also suggests height—he's outgrowing it!

Tall boots

Shorter on the top half...

...and longer on the bottom half—shows height

This wizard is 7½ heads tall.

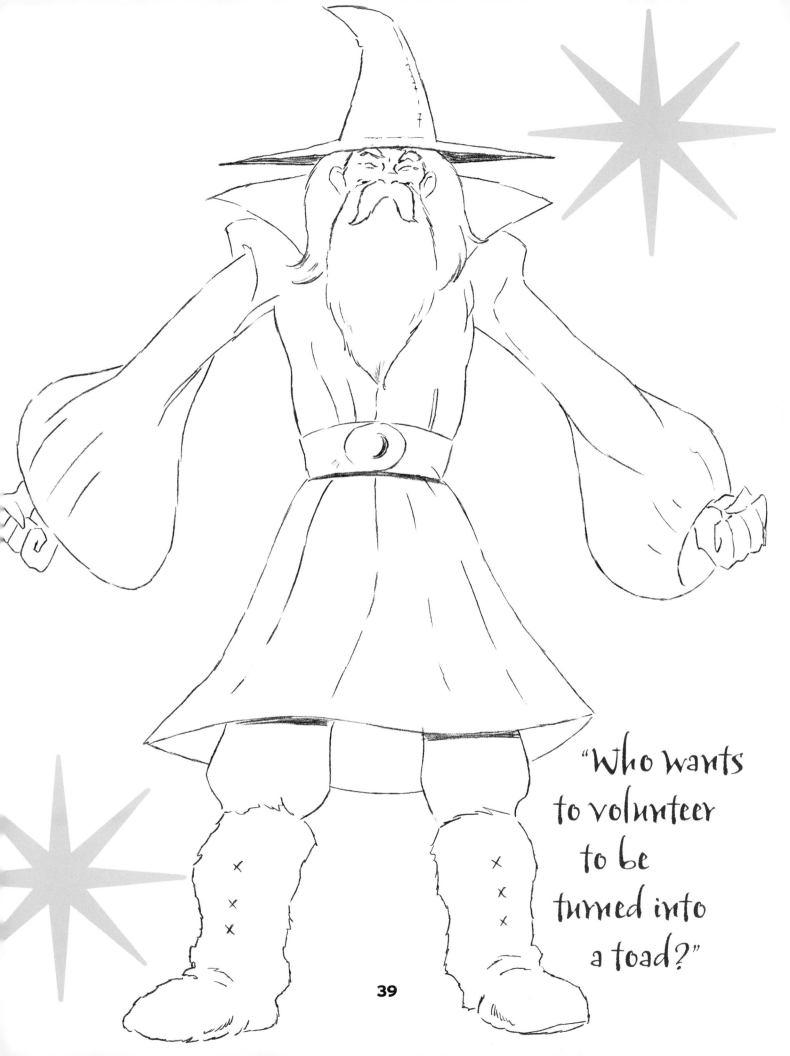

"Who wants to volunteer to be turned into a toad?"

39

Towering Wizard

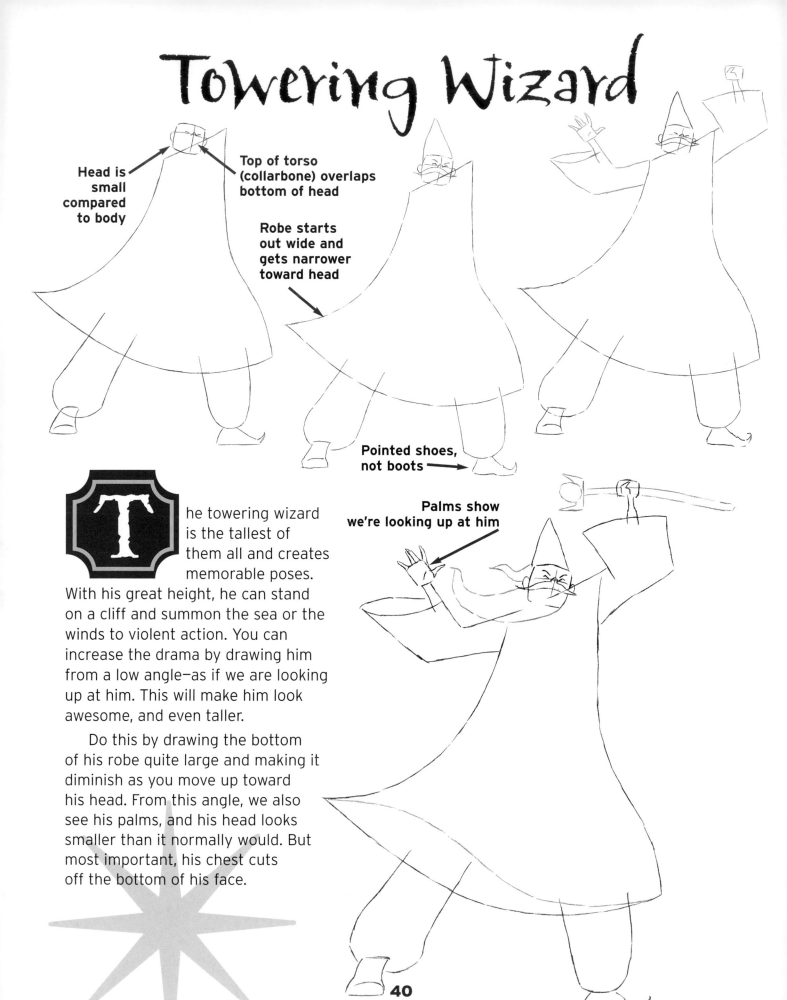

Head is small compared to body

Top of torso (collarbone) overlaps bottom of head

Robe starts out wide and gets narrower toward head

Pointed shoes, not boots

Palms show we're looking up at him

The towering wizard is the tallest of them all and creates memorable poses. With his great height, he can stand on a cliff and summon the sea or the winds to violent action. You can increase the drama by drawing him from a low angle—as if we are looking up at him. This will make him look awesome, and even taller.

Do this by drawing the bottom of his robe quite large and making it diminish as you move up toward his head. From this angle, we also see his palms, and his head looks smaller than it normally would. But most important, his chest cuts off the bottom of his face.

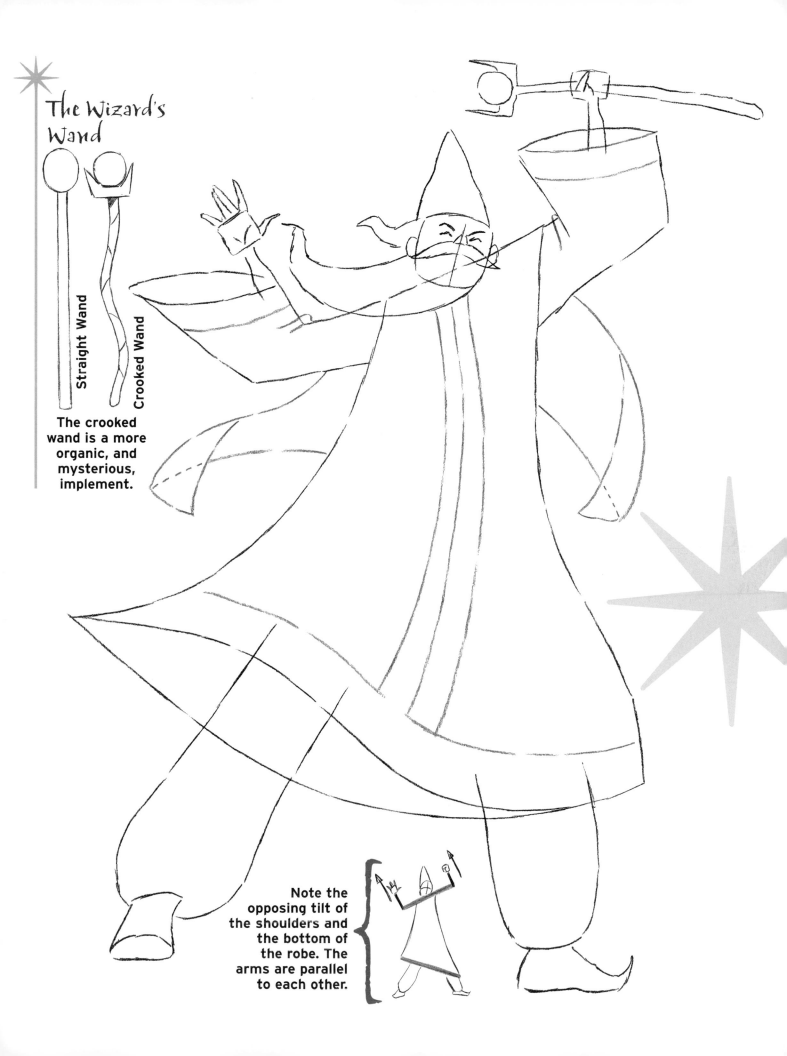

The Wizard's Wand

Straight Wand

Crooked Wand

The crooked wand is a more organic, and mysterious, implement.

Note the opposing tilt of the shoulders and the bottom of the robe. The arms are parallel to each other.

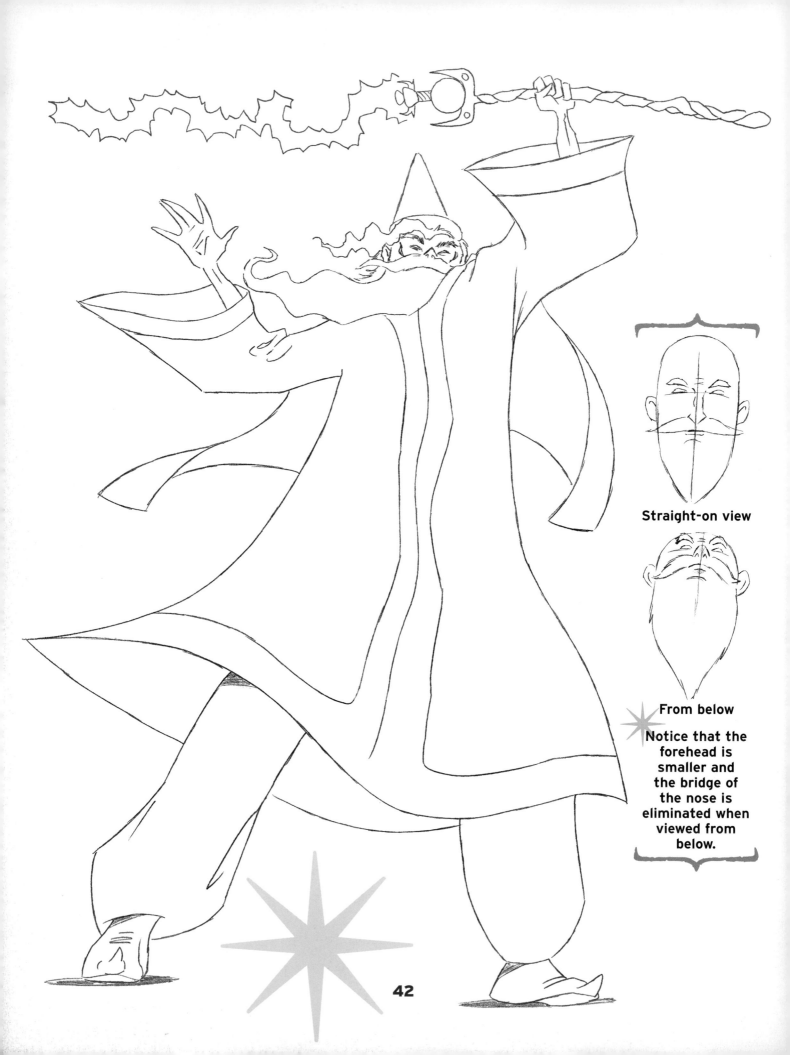

Straight-on view

From below

Notice that the forehead is smaller and the bridge of the nose is eliminated when viewed from below.

42

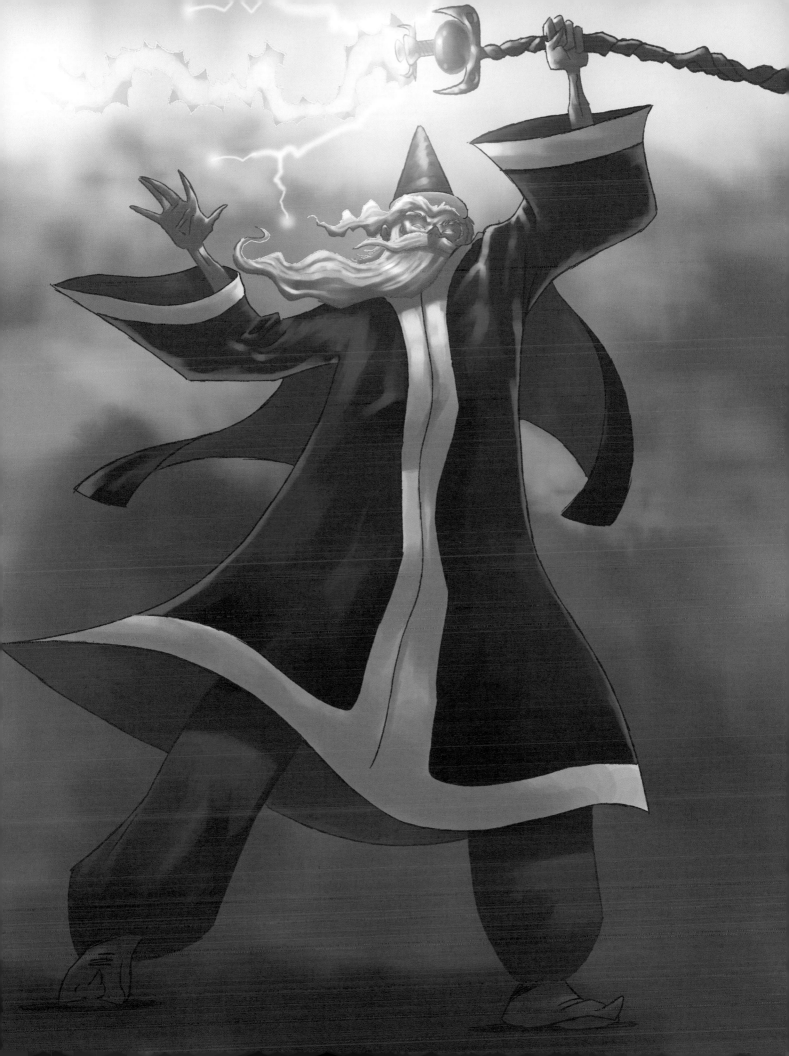

Beings of Darkness
Trolls, Goblins & More

These are the bewitched creatures, victims of spells so strong that they have been changed both physically and spiritually. They are no longer human, but beings of darkness who cannot be trusted. They are all forest dwellers, and it is best to avoid running into them in your travels through the woods.

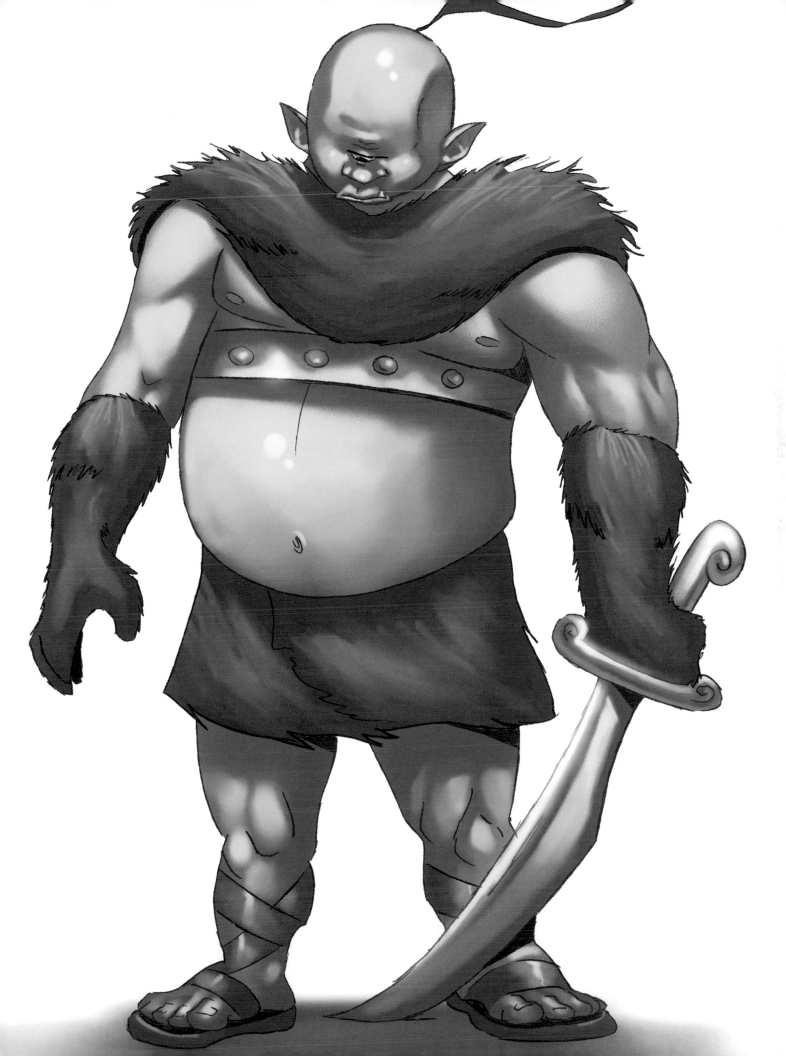

Ogres

The ogre may seem slow and dimwitted, but he is single-minded in his desire to defend his territory. If you happen to meet one, it means you have strayed into his domain, and ogres do <u>not</u> accept apologies.

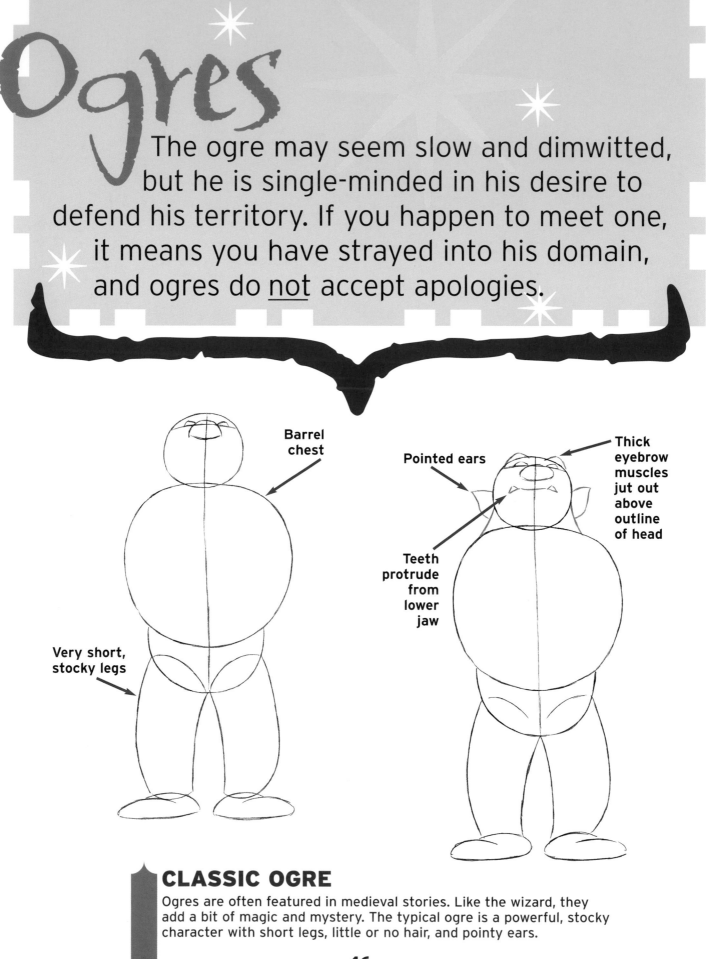

Barrel chest

Very short, stocky legs

Pointed ears

Teeth protrude from lower jaw

Thick eyebrow muscles jut out above outline of head

CLASSIC OGRE

Ogres are often featured in medieval stories. Like the wizard, they add a bit of magic and mystery. The typical ogre is a powerful, stocky character with short legs, little or no hair, and pointy ears.

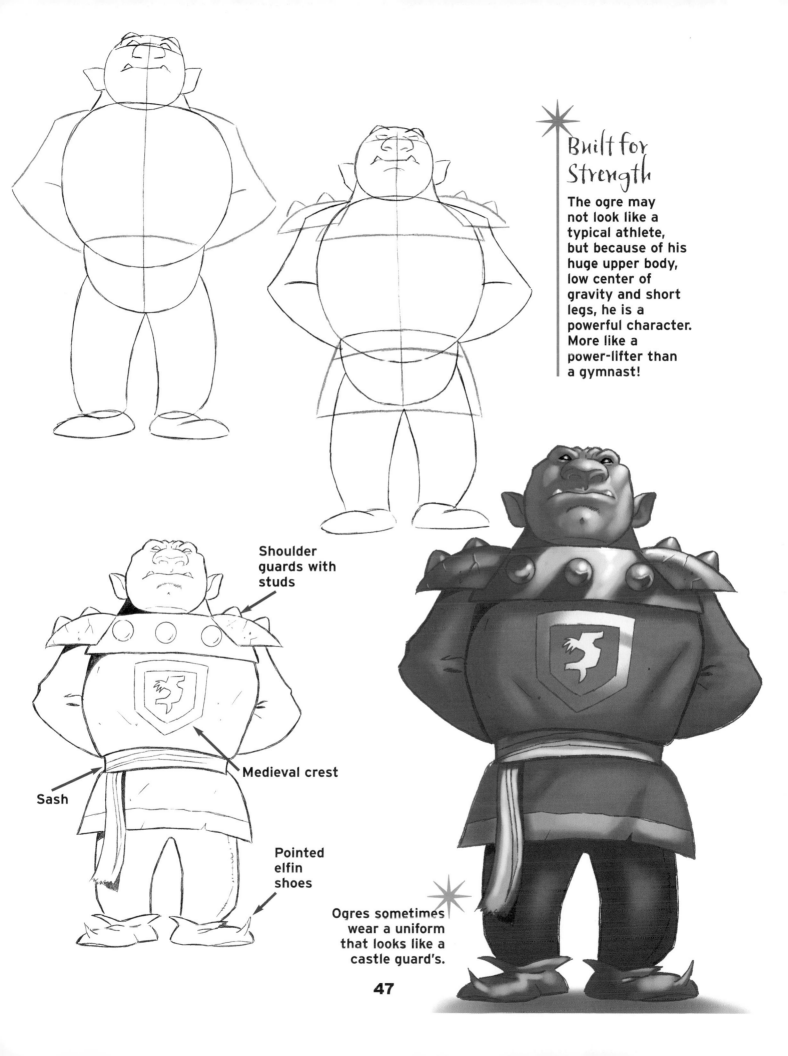

Built for Strength

The ogre may not look like a typical athlete, but because of his huge upper body, low center of gravity and short legs, he is a powerful character. More like a power-lifter than a gymnast!

Shoulder guards with studs

Medieval crest

Sash

Pointed elfin shoes

Ogres sometimes wear a uniform that looks like a castle guard's.

47

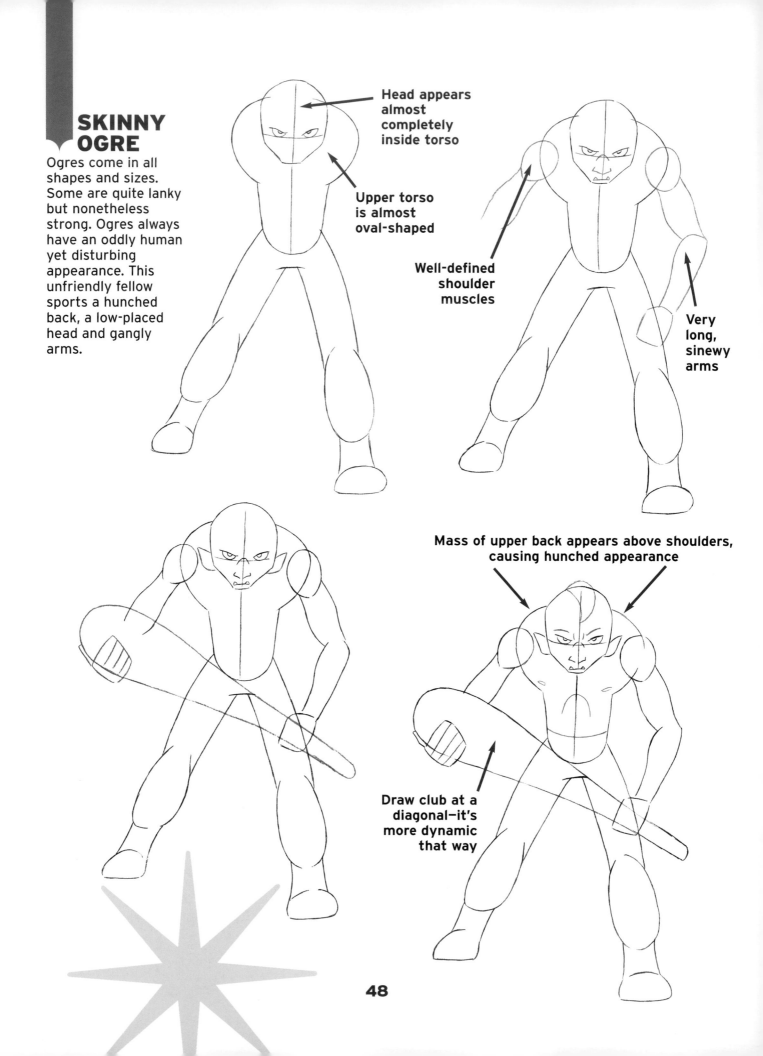

SKINNY OGRE

Ogres come in all shapes and sizes. Some are quite lanky but nonetheless strong. Ogres always have an oddly human yet disturbing appearance. This unfriendly fellow sports a hunched back, a low-placed head and gangly arms.

Head appears almost completely inside torso

Upper torso is almost oval-shaped

Well-defined shoulder muscles

Very long, sinewy arms

Mass of upper back appears above shoulders, causing hunched appearance

Draw club at a diagonal—it's more dynamic that way

48

No!
Fingernails do not sprout out of the tips of fingers

Yes!
Fingernails are embedded deep within the fingertip

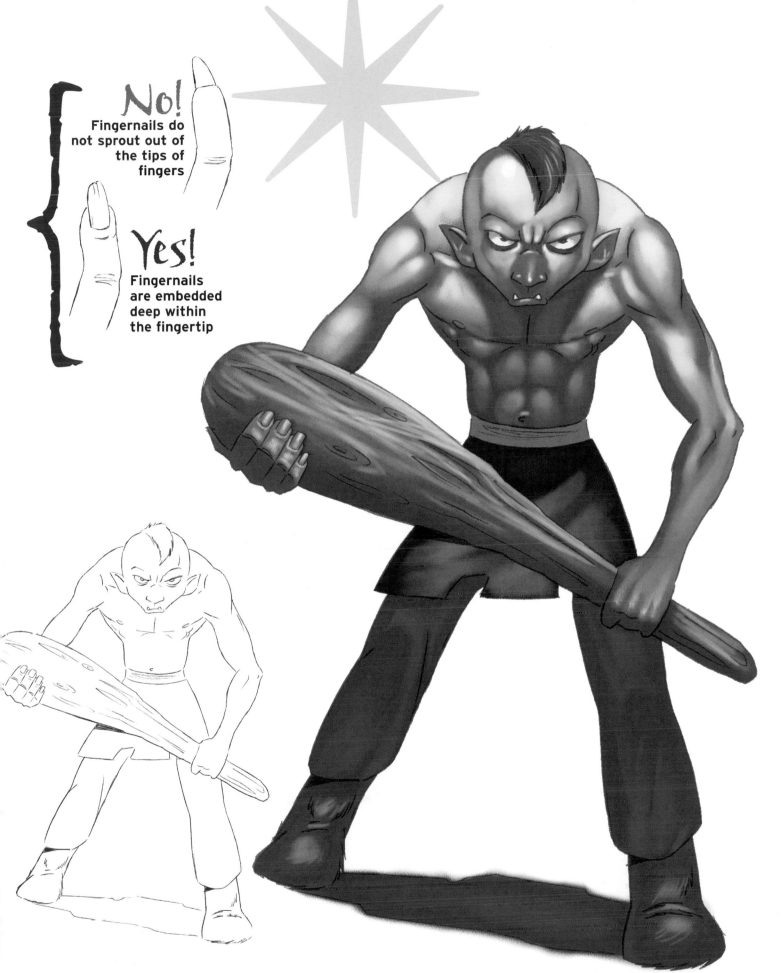

If you run into this fella on a dark night, I suggest you keep moving...and don't ever look back!

THE AXE-WIELDER

Characters with axes usually have big muscles—that axe is heavy! This ogre's brow is low on his head, giving him a stupid look. And his upper lip is exceedingly long, typical of ogres. The exaggerated upper lip creates a divergence from the human form and, together with the pointed ears and abnormally muscular brow, puts him squarely in the fantasy realm.

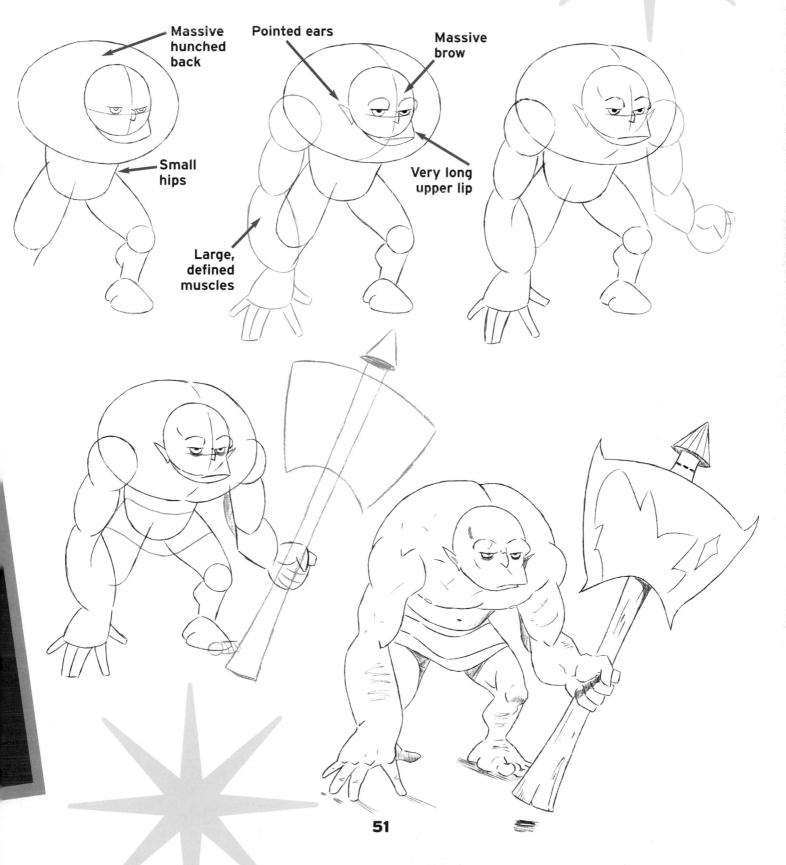

Massive hunched back

Small hips

Pointed ears

Massive brow

Very long upper lip

Large, defined muscles

51

THE BRUTE

The key word for this type of ogre is "massive": massive cranium, massive forehead bone, massive eyebrow muscles and massive neck. And by placing the mouth so high up on the face, the chin gains a lot of mass as well.

Half-shut eye looks malformed

Immense neck starts way up at base of skull

Pointed brow protrudes far beyond outline of head

Sharp cheekbones give him a lean, hungry look

Blood vessels at temples show intensity

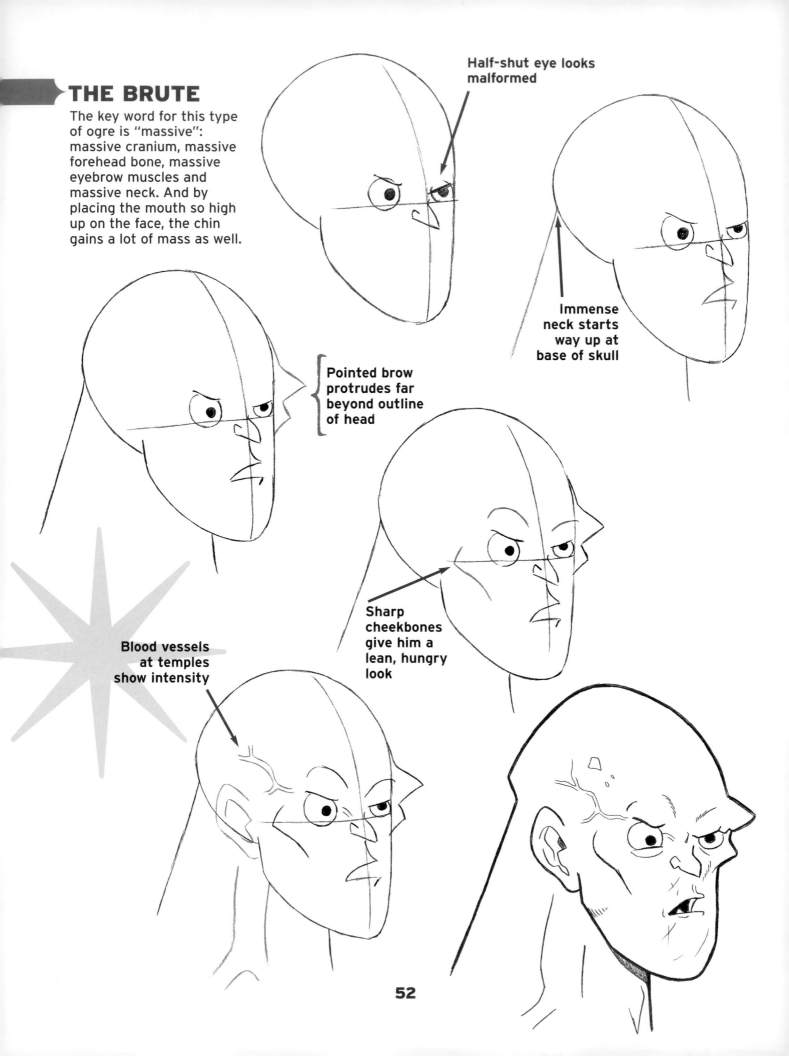

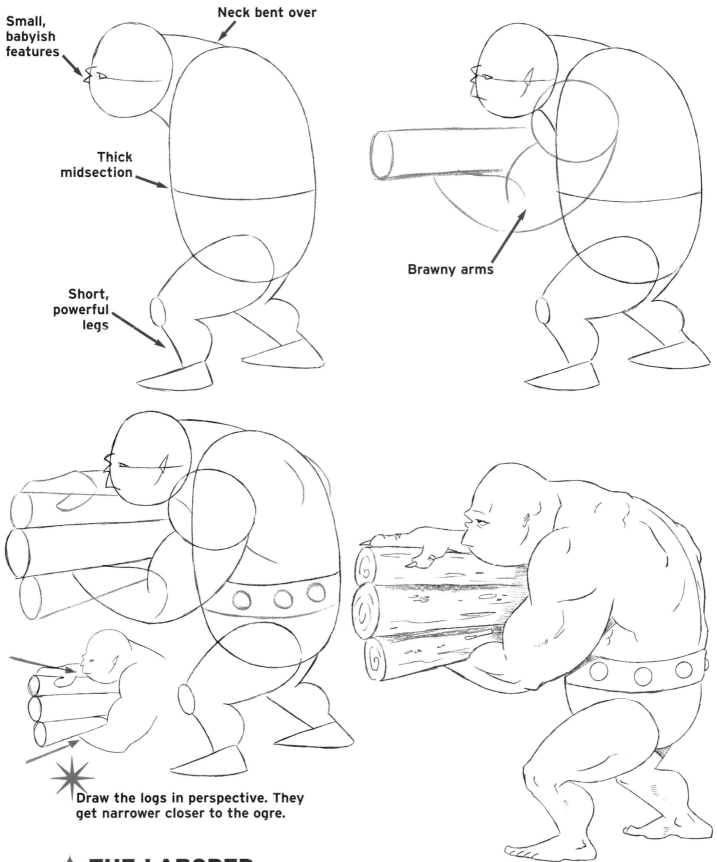

Small, babyish features

Neck bent over

Thick midsection

Short, powerful legs

Brawny arms

Draw the logs in perspective. They get narrower closer to the ogre.

THE LABORER

The ogres who work for the kingdom are generally docile, like mules. But when provoked, they go on a real tear. They are tall and thick in the middle. They also have baby-like faces with small features. Like all ogres, they have a bent-over posture.

THE KING'S SERVANT
An ogre has the strength of several men, so they are sometimes employed to pull carts or even carry the king. In this role, an ogre can be drawn as a big-buddy type or bodyguard character.

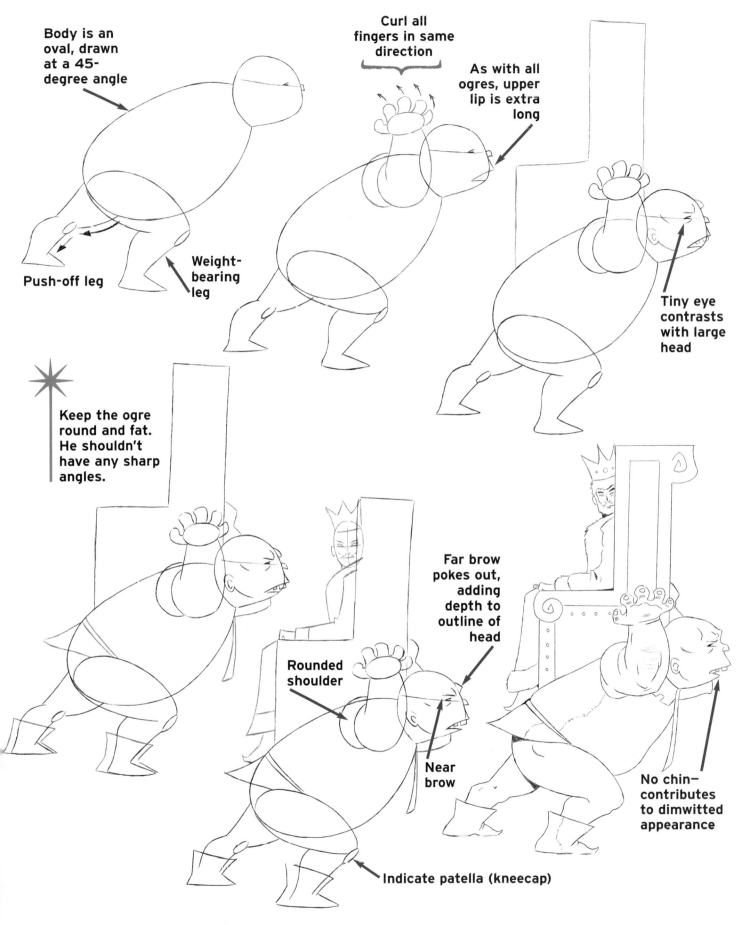

Body is an oval, drawn at a 45-degree angle

Push-off leg

Weight-bearing leg

Curl all fingers in same direction

As with all ogres, upper lip is extra long

Tiny eye contrasts with large head

Keep the ogre round and fat. He shouldn't have any sharp angles.

Rounded shoulder

Far brow pokes out, adding depth to outline of head

Near brow

Indicate patella (kneecap)

No chin—contributes to dimwitted appearance

55

The Dreaded Cyclops

This one-eyed monster is a demi-giant with an imposing frame and a small, round head. Made famous in Greek mythology, the cyclops is known for brute strength and an unpleasant disposition.

BARBARIAN CYCLOPS

This fighting fantasy figure looks good with a few well-positioned props. The fur garment slung around his shoulders makes his shoulders look even more impressive. Note how his chin rests upon his chest. It's a posture of strength and authority, from which he surveys the world below him.

Eye placed low on head

Super-thick neck gets very wide at base

Thick upper leg

Lower leg tapers slightly

Broad, square
shoulders

Animal skin dips
in middle...

...then wraps
around
shoulders

The cyclops is
big and mean.
He watches
everything with a
detached look,
knowing that he
can do what he
wants and nobody
can do anything
to stop him.

Ponytail

Animal skin

Straps and
studs

Animal
skin

Long,
thick
sword
with
curved
blade

Animal
skin

Sandals with straps

57

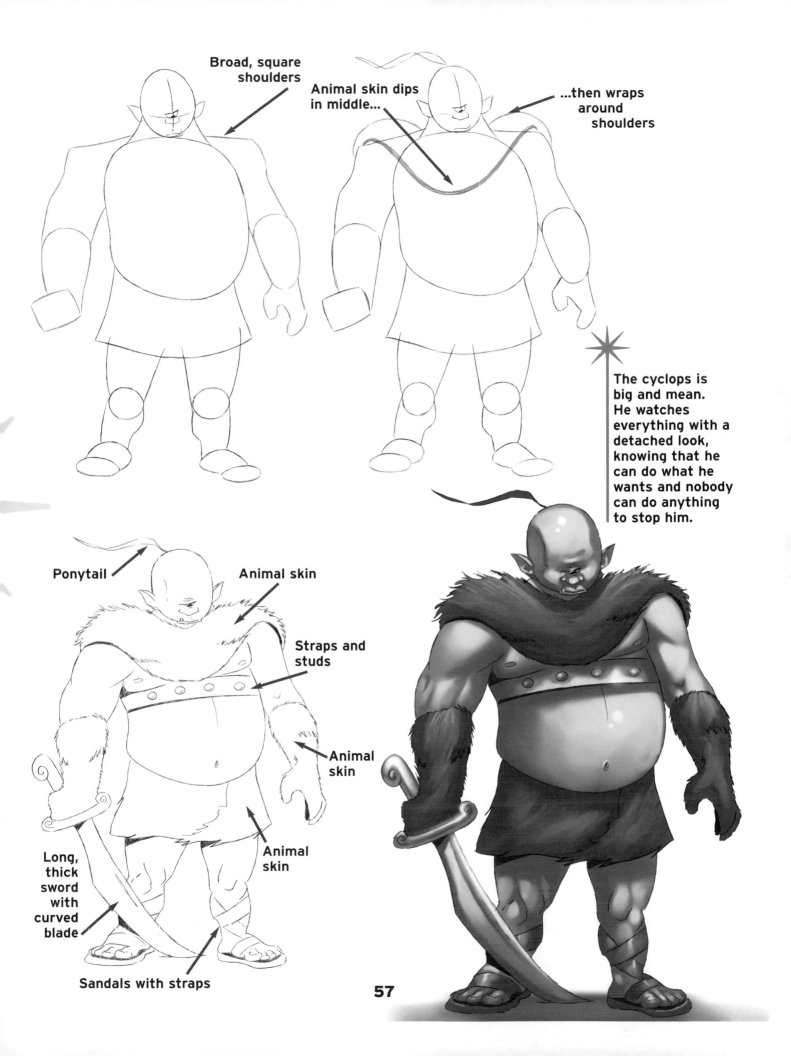

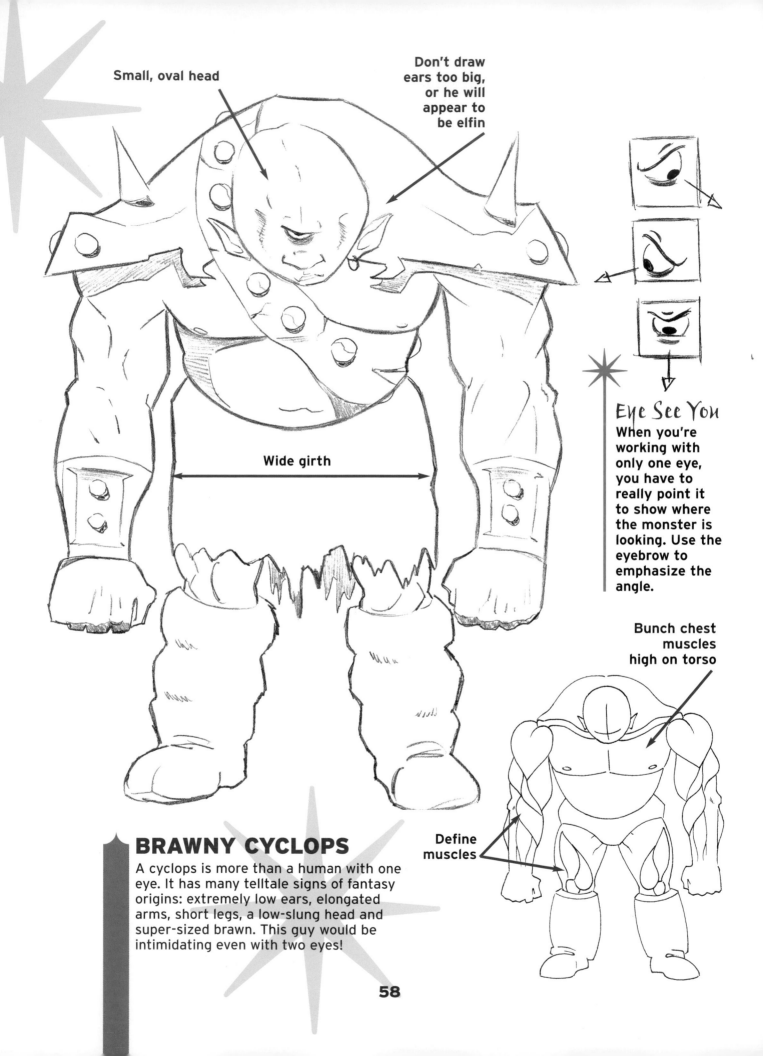

Small, oval head

Don't draw ears too big, or he will appear to be elfin

Wide girth

Eye See You

When you're working with only one eye, you have to really point it to show where the monster is looking. Use the eyebrow to emphasize the angle.

Bunch chest muscles high on torso

Define muscles

BRAWNY CYCLOPS

A cyclops is more than a human with one eye. It has many telltale signs of fantasy origins: extremely low ears, elongated arms, short legs, a low-slung head and super-sized brawn. This guy would be intimidating even with two eyes!

Tiny Trolls

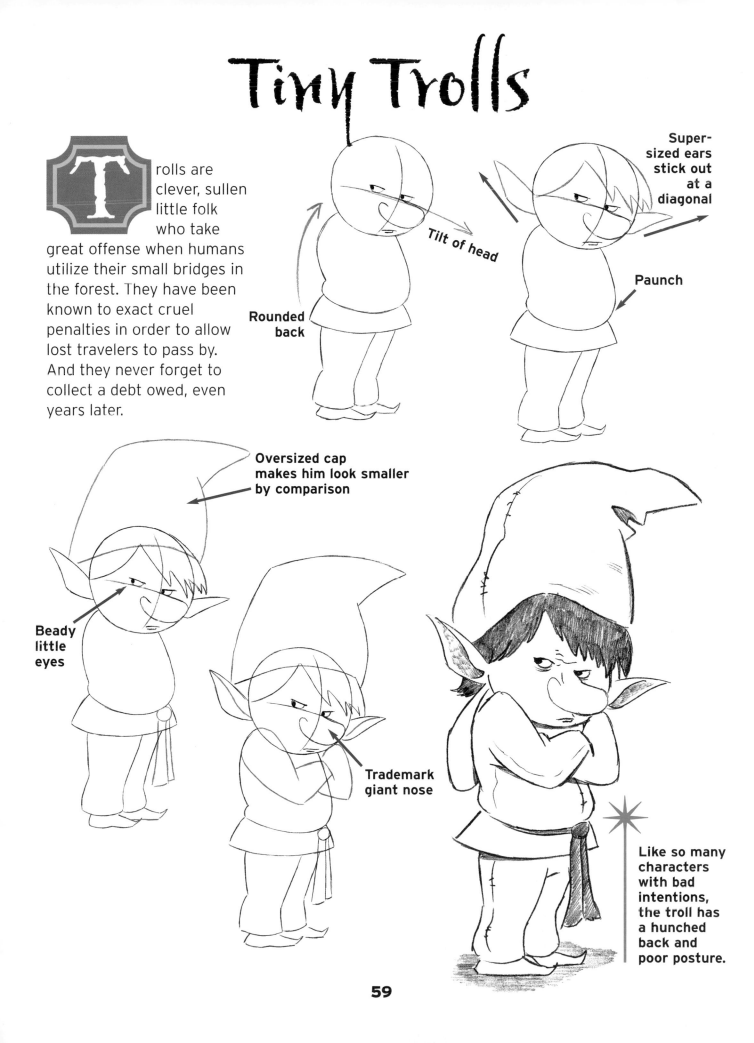

Trolls are clever, sullen little folk who take great offense when humans utilize their small bridges in the forest. They have been known to exact cruel penalties in order to allow lost travelers to pass by. And they never forget to collect a debt owed, even years later.

Tilt of head

Rounded back

Super-sized ears stick out at a diagonal

Paunch

Oversized cap makes him look smaller by comparison

Beady little eyes

Trademark giant nose

Like so many characters with bad intentions, the troll has a hunched back and poor posture.

Goblins

Goblins are eerie monsters, with quirky personalities. Their expressive faces and body language make them curiously appealing fantasy characters.

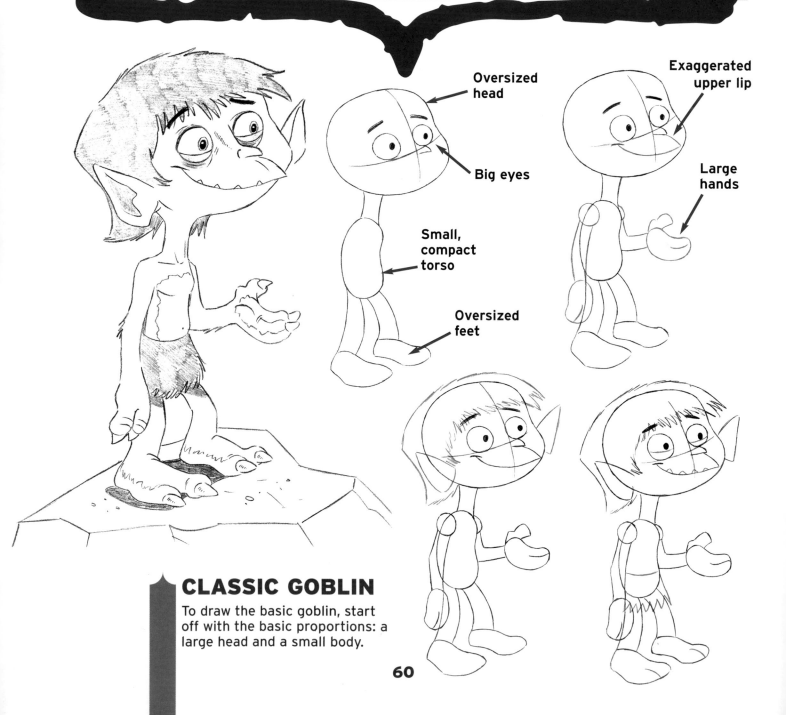

Oversized head

Big eyes

Small, compact torso

Oversized feet

Exaggerated upper lip

Large hands

CLASSIC GOBLIN

To draw the basic goblin, start off with the basic proportions: a large head and a small body.

GREEDY GOBLIN

When drawing a character, use the entire body—not just the face—as a source of expression. The "pull-push" principle is applied here. As one part of the body pushes down to get a closer look at the treasure, another pulls up in surprise and amazement—a naturally occurring counterbalance. This technique turns a static pose into a dynamic one.

Lift the arms for a surprised body attitude.

TIMID GOBLIN

This nervous little goblin has more human proportions than the classic goblin, with smaller hands and feet, but still an oversized head. He looks so pitiful it's hard to believe he's a monster at all!

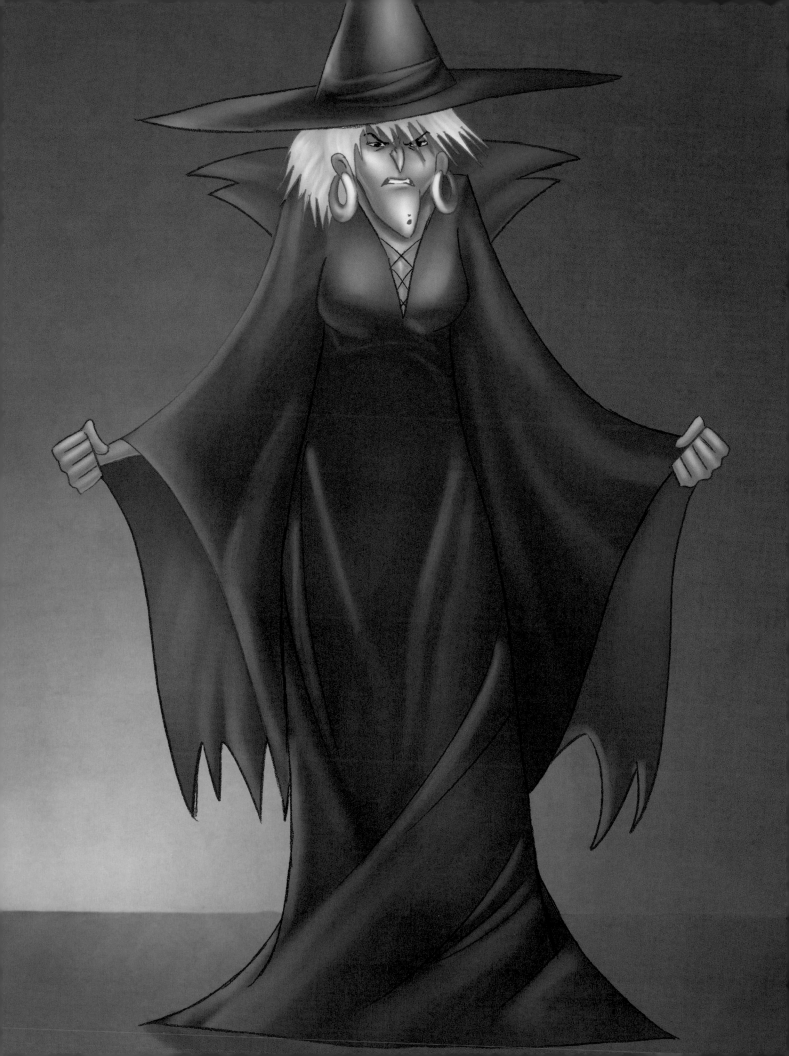

The Witches' Coven

We mortals have a fascination with witches.

The typical witch, with her hideous appearance and knowledge of potions and spells, captures our curiosity. Her cackling laugh is infamous, but her temper is also legendary: You never want to get on her bad side. The witch is an enigma, mysterious and charismatic, humorous as well as frightening. And she's sure to be with us in fantasy adventures for ages to come.

Classic Hag Witch

This type of witch is a perennial favorite of fantasy artists and readers. Let's get a general impression before we begin to draw. What traits really stick out? She's got wide hips, making her look slightly frumpy. Give her narrow shoulders and spindly wrists.

We have eliminated her neck by placing her head low on her shoulders, giving her a slightly hunched appearance. And those rags that double as clothes should have jagged edges on the sleeves and possibly on the hem, too.

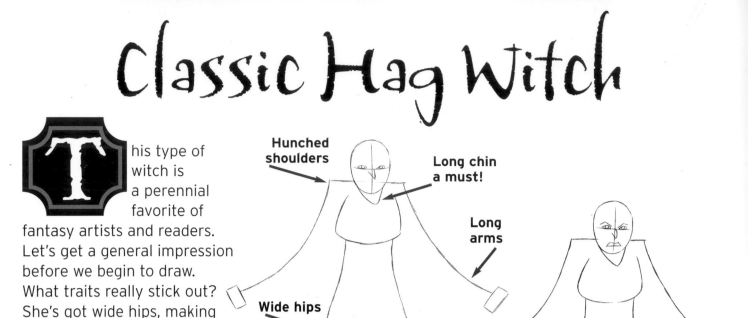

Hunched shoulders

Long chin a must!

Long arms

Wide hips

Far edge of sleeve

Near edge of sleeve

Brim covers most of forehead

Dress spreads out at the ground

64

Witches have two major emotions: anger and syrupy sweet insincerity.

LOOSE SKETCH

Because this pose is so straightforward and symmetrical, I found it easy to capture on the first try. In the finished version, I shortened her hair to give her a more severe look. Note her beady little eyes—a hallmark of deceitful characters of all shapes and sizes.

Crooked-Nose Witch

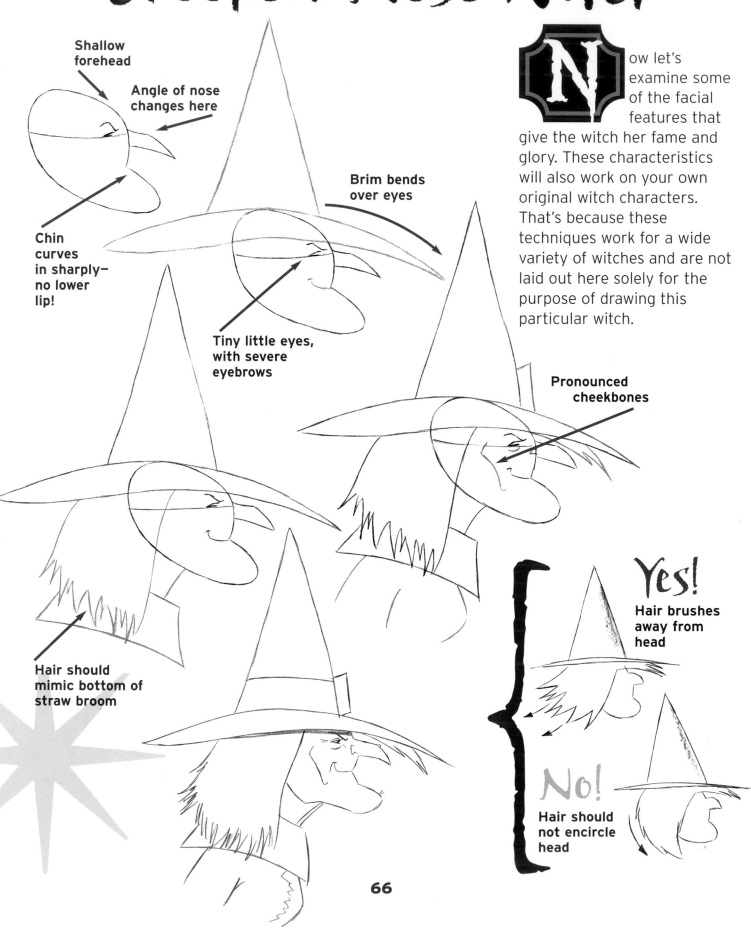

Shallow forehead

Angle of nose changes here

Chin curves in sharply— no lower lip!

Brim bends over eyes

Tiny little eyes, with severe eyebrows

ow let's examine some of the facial features that give the witch her fame and glory. These characteristics will also work on your own original witch characters. That's because these techniques work for a wide variety of witches and are not laid out here solely for the purpose of drawing this particular witch.

Pronounced cheekbones

Hair should mimic bottom of straw broom

Yes!
Hair brushes away from head

No!
Hair should not encircle head

Cackling Witch

Draw nose crooked, even in front view

The witch's cackle is nothing to laugh about! It usually means that you've stepped into a world of trouble. The off-center mouth, in combination with mean eyes, darkens the smile. Note the extremely heavy mascara, making her look like a crazy old lady—which she is! A single bottom tooth is a nice touch.

Witchy hands sport long, skinny fingers, bony knuckles, and long fingernails.

Collar is an upside-down triangle.

Give skinny arms very tiny wrists!

The Witch's Tools

It takes more than a wand to mess around with spells and potions. The witch's paraphernalia adds to the fun of the scene and brings out the excitement of the magic. These accoutrements are most often used for casting spells and chanting incantations. Some, like pendants, are small. More ambitious spells require giant cauldrons.

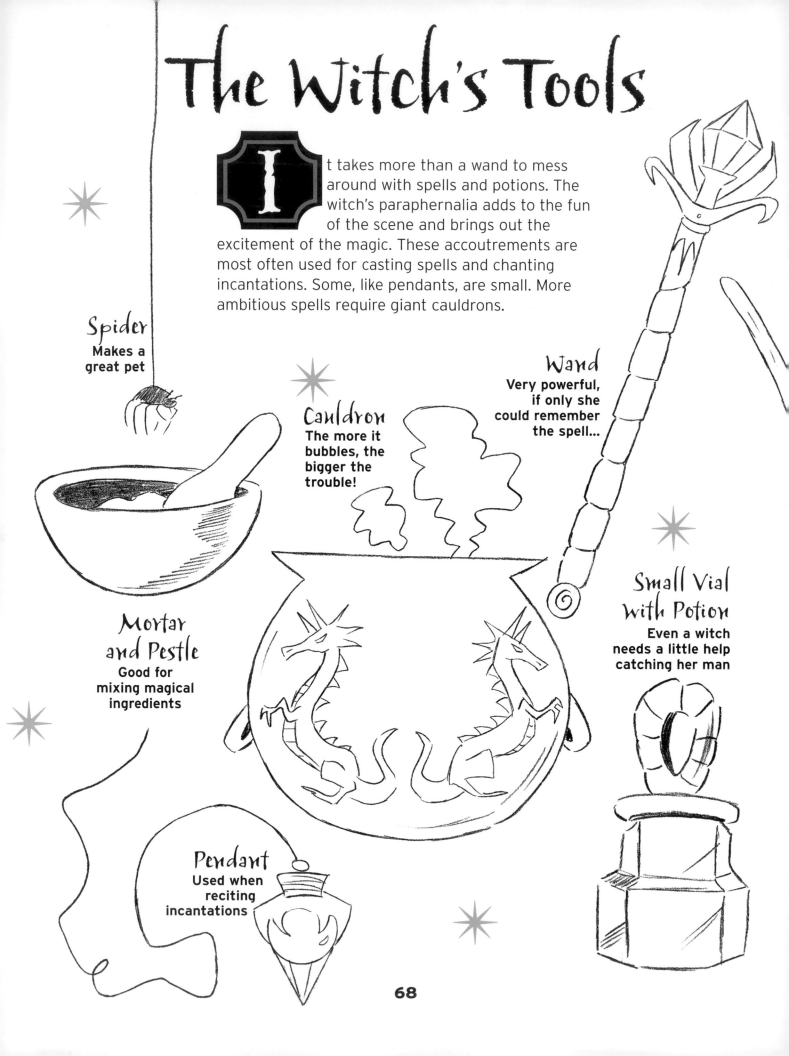

Spider
Makes a great pet

Cauldron
The more it bubbles, the bigger the trouble!

Wand
Very powerful, if only she could remember the spell...

Mortar and Pestle
Good for mixing magical ingredients

Small Vial with Potion
Even a witch needs a little help catching her man

Pendant
Used when reciting incantations

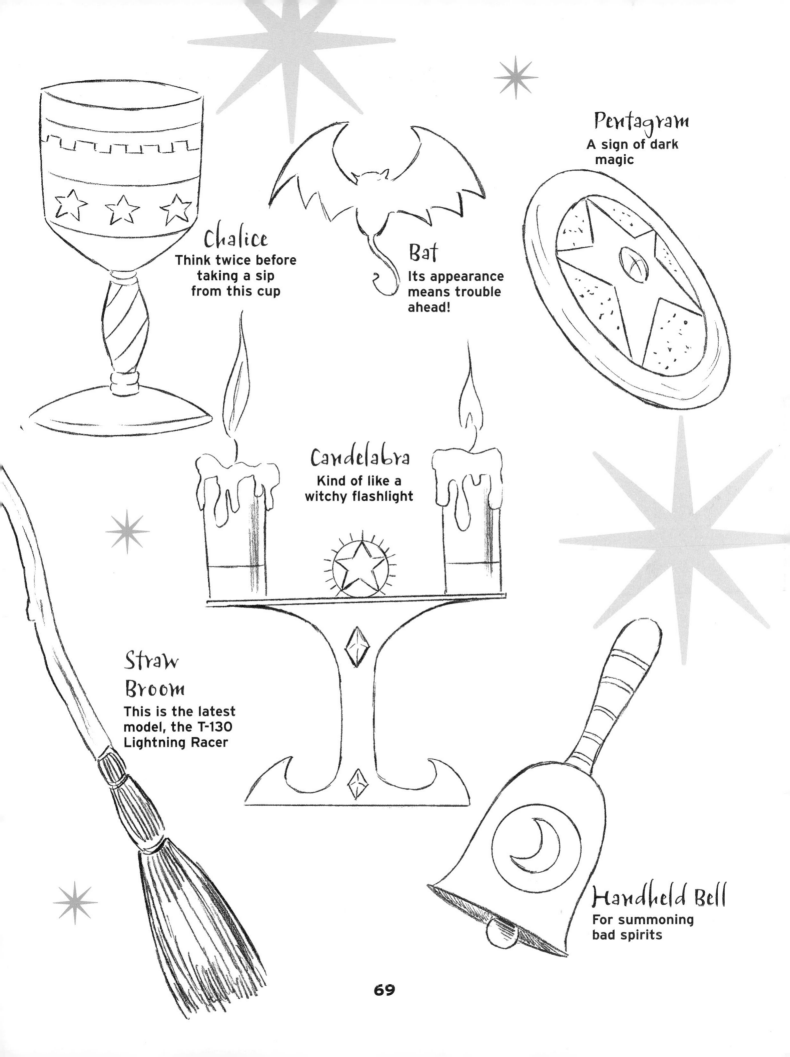

Chalice
Think twice before taking a sip from this cup

Bat
Its appearance means trouble ahead!

Pentagram
A sign of dark magic

Candelabra
Kind of like a witchy flashlight

Straw Broom
This is the latest model, the T-130 Lightning Racer

Handheld Bell
For summoning bad spirits

69

Black Cats & Witches

The poor black cat. Sometimes he's a treasured pet. At other times, he makes the ideal subject for practice spells. In the world of witches, the black cat may not be a cat at all, but a bewitched person in the body of a cat. But let's suppose that this guy really is a kitty. You have a choice, as the artist, whether to make him a friend of the witch or an antagonist.

Brim of hat
intersects
forehead

Give tail a
serpentine
"S" curve

Thigh
bunches up

Skinny + slinky = evil

For fun, "float"
the name tag

DRAWING THE BLACK CAT

Black cats and witches go together like a
boy and his dog. The cat can spy on people,
unnoticed, and run back to report to the
witch what it has observed.

71

Pretty Witches

Young, pretty witches are a popular addition to the fantasy genre. They wear the same basic outfits as their crotchety seniors, but their youthful figures make them look attractive.

A NIGHT OF FLIGHT

Riding sidesaddle on a broom is an appealing look. It's also less old-fashioned than the standard horseback style we've all seen a hundred times.

As the witch is whisked forward by her broom, her body tugs backwards (Newton's law of opposite and equal reactions is at work here). Instead of drawing the broom as parallel to the earth below, tilt it up, so it appears to be ascending. Last, her hair and clothing should be flapping in the wind to show movement through the night sky.

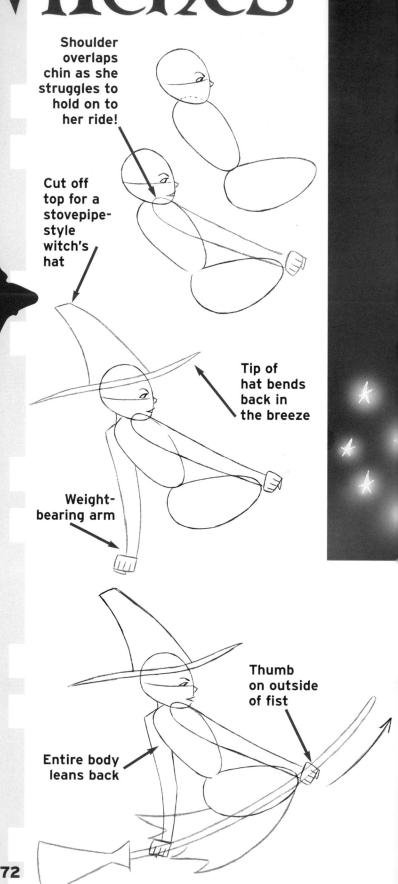

Shoulder overlaps chin as she struggles to hold on to her ride!

Cut off top for a stovepipe-style witch's hat

Tip of hat bends back in the breeze

Weight-bearing arm

Thumb on outside of fist

Entire body leans back

The Pilgrim-style ✴ outfit is a popular look for a pretty witch.

The pretty witch's forehead has a sweeping, feminine curve.

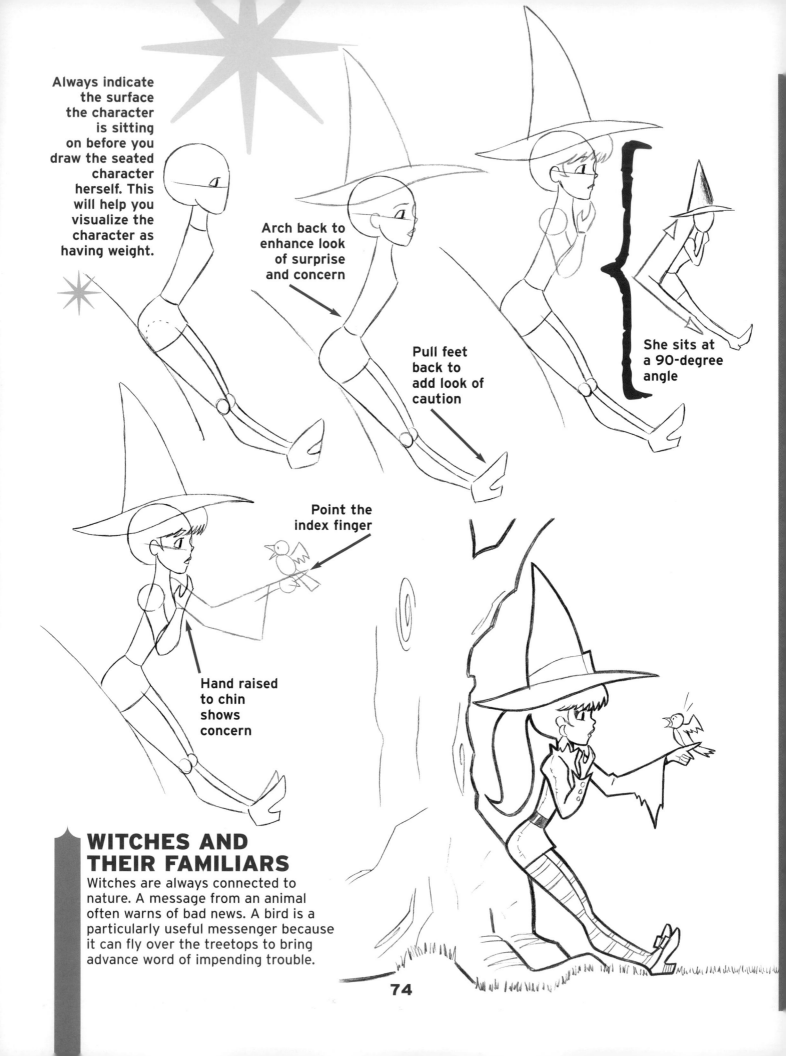

Always indicate the surface the character is sitting on before you draw the seated character herself. This will help you visualize the character as having weight.

Arch back to enhance look of surprise and concern

Pull feet back to add look of caution

She sits at a 90-degree angle

Point the index finger

Hand raised to chin shows concern

WITCHES AND THEIR FAMILIARS

Witches are always connected to nature. A message from an animal often warns of bad news. A bird is a particularly useful messenger because it can fly over the treetops to bring advance word of impending trouble.

74

"I've got some good news and some bad news. Which do you want first?"

Communicating with Animals

Showing a bird fluttering in midair may look too frantic. All that furious flapping to keep itself aloft could be misinterpreted as anger. (Besides, no birds, besides hummingbirds, have the ability to "tread air.") Perching the bird on the witch's finger looks natural and instantly shows their rapport.

Fashionable Witches

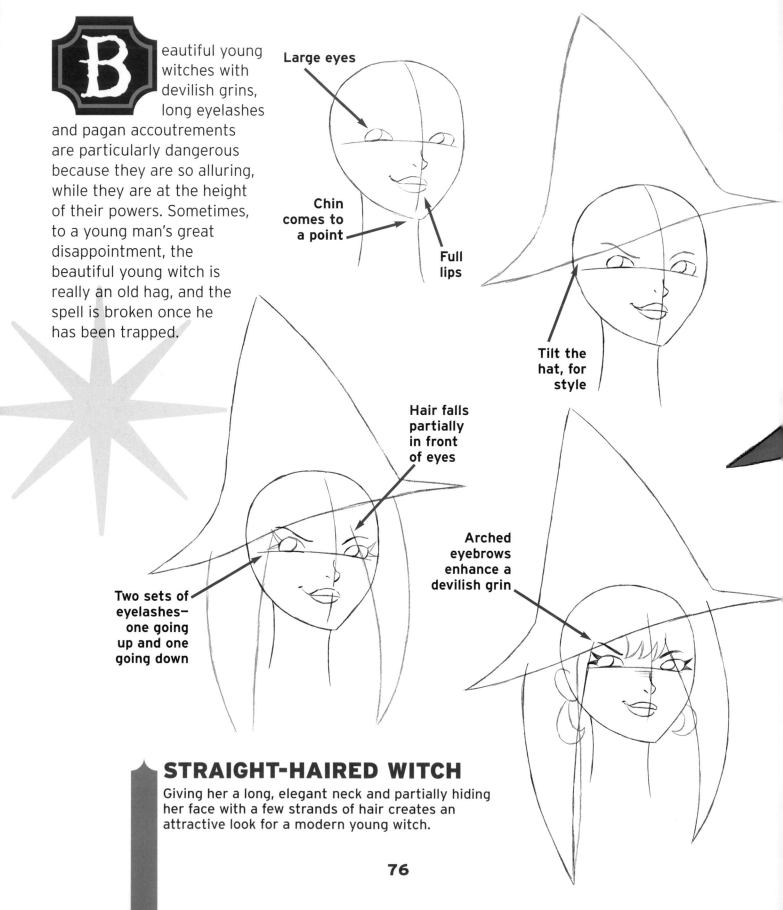

Beautiful young witches with devilish grins, long eyelashes and pagan accoutrements are particularly dangerous because they are so alluring, while they are at the height of their powers. Sometimes, to a young man's great disappointment, the beautiful young witch is really an old hag, and the spell is broken once he has been trapped.

Large eyes

Chin comes to a point

Full lips

Tilt the hat, for style

Hair falls partially in front of eyes

Two sets of eyelashes— one going up and one going down

Arched eyebrows enhance a devilish grin

STRAIGHT-HAIRED WITCH
Giving her a long, elegant neck and partially hiding her face with a few strands of hair creates an attractive look for a modern young witch.

76

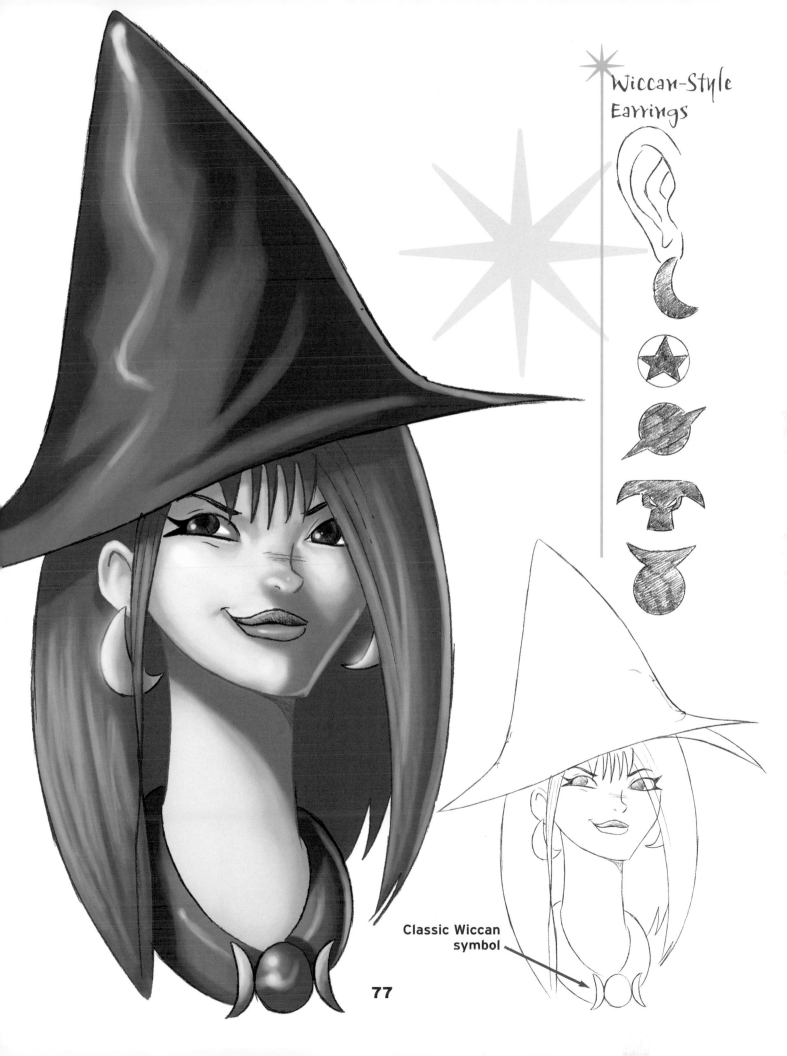

Wiccan-Style Earrings

Classic Wiccan symbol

77

CURLY-HAIRED WITCH

Long, curly hair is actually drawn the same way that fire is drawn, so it's no surprise that this character is a fiery one. Note the dynamic pose: The trunk actually twists. You can see that by following the center line down the center of the torso. Her shoulders are raised in a flirtatious pose.

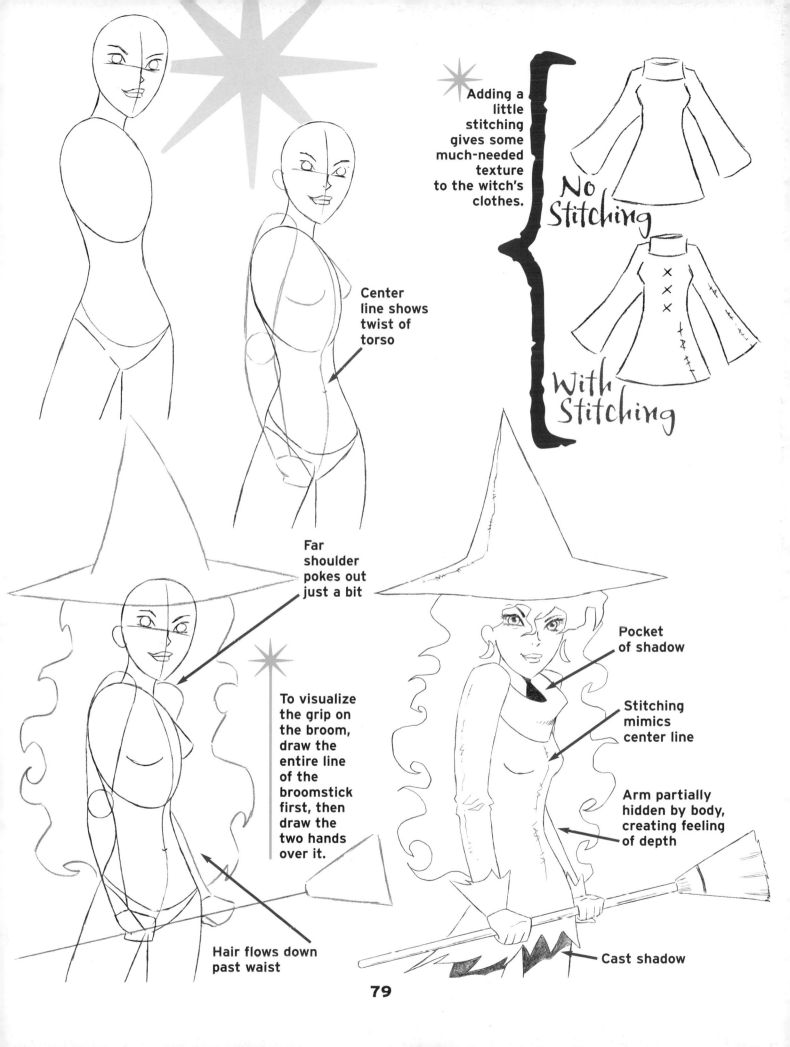

Center line shows twist of torso

Adding a little stitching gives some much-needed texture to the witch's clothes.

No Stitching

With Stitching

Far shoulder pokes out just a bit

To visualize the grip on the broom, draw the entire line of the broomstick first, then draw the two hands over it.

Hair flows down past waist

Pocket of shadow

Stitching mimics center line

Arm partially hidden by body, creating feeling of depth

Cast shadow

79

Witches-in-Training

When they are very young, some girls realize that they are actually witches whose parents are unaware of their powers. These girls will often hide their special abilities from their own family and friends. But they will be instantly recognized for who they are by other witches, who will often offer to mentor the girls and show them how to harness and control their "gift."

A touch of her hand and the transfer of powers will begin!

Teen Witch

Here's a modern teenage witch. Her outfit is a combination of private-school uniform and witch's outfit. The striped leggings are a classic teen-witch look. One word of caution: When there are conventions that work well and are accepted widely, don't break them unless you have a compelling reason. One such convention is that teen witches are always attractive. Another is that pretty witches are most often "good" witches.

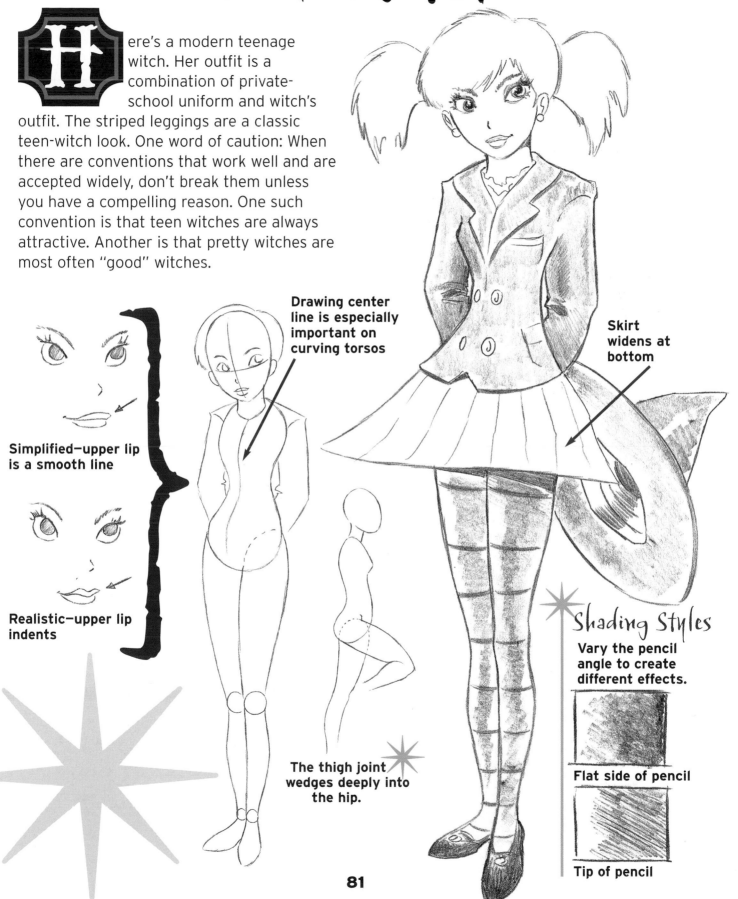

Drawing center line is especially important on curving torsos

Simplified—upper lip is a smooth line

Realistic—upper lip indents

Skirt widens at bottom

The thigh joint wedges deeply into the hip.

Shading Styles

Vary the pencil angle to create different effects.

Flat side of pencil

Tip of pencil

81

Girl Witch

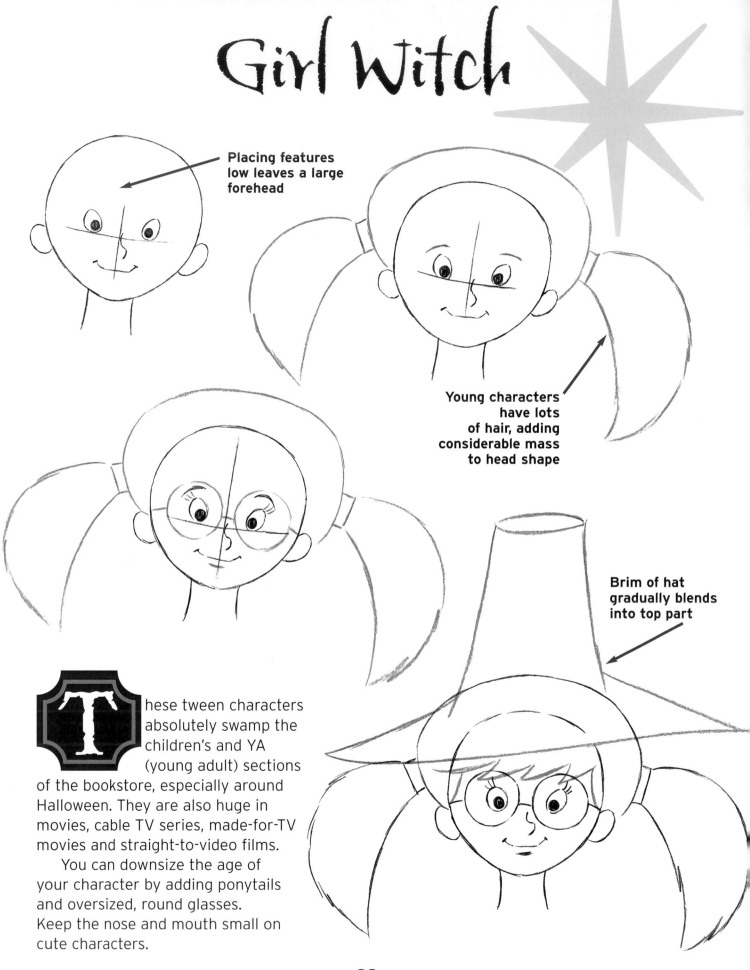

Placing features low leaves a large forehead

Young characters have lots of hair, adding considerable mass to head shape

Brim of hat gradually blends into top part

These tween characters absolutely swamp the children's and YA (young adult) sections of the bookstore, especially around Halloween. They are also huge in movies, cable TV series, made-for-TV movies and straight-to-video films.

You can downsize the age of your character by adding ponytails and oversized, round glasses. Keep the nose and mouth small on cute characters.

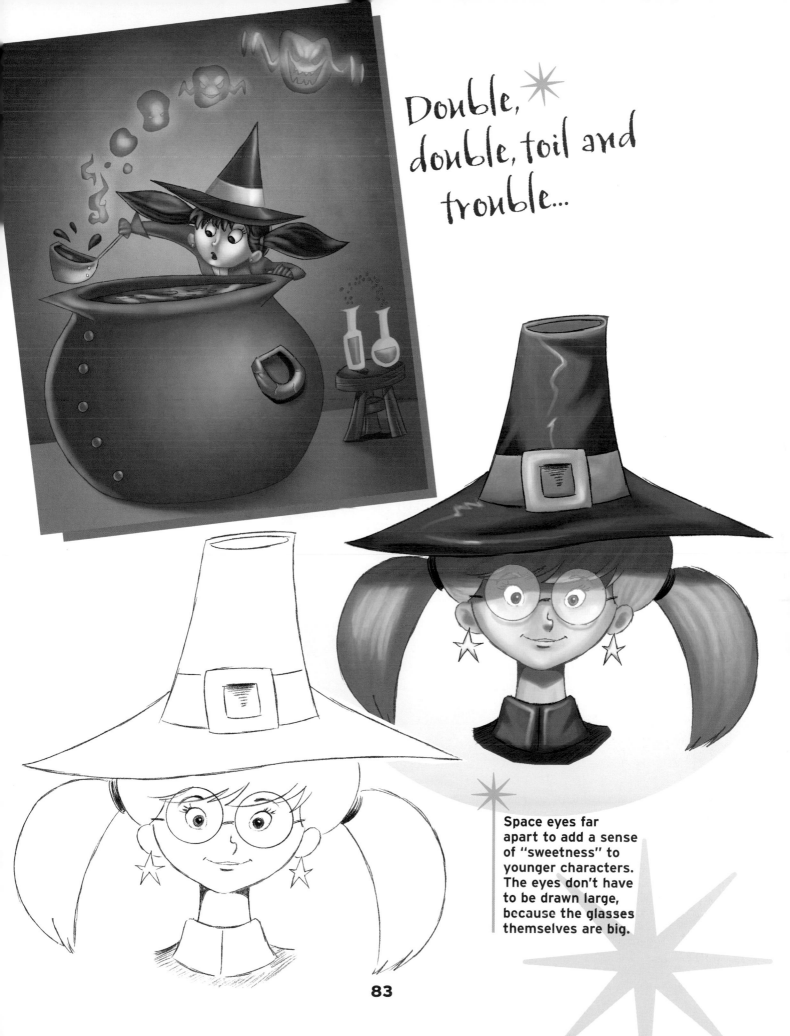

Double, double, toil and trouble...

Space eyes far apart to add a sense of "sweetness" to younger characters. The eyes don't have to be drawn large, because the glasses themselves are big.

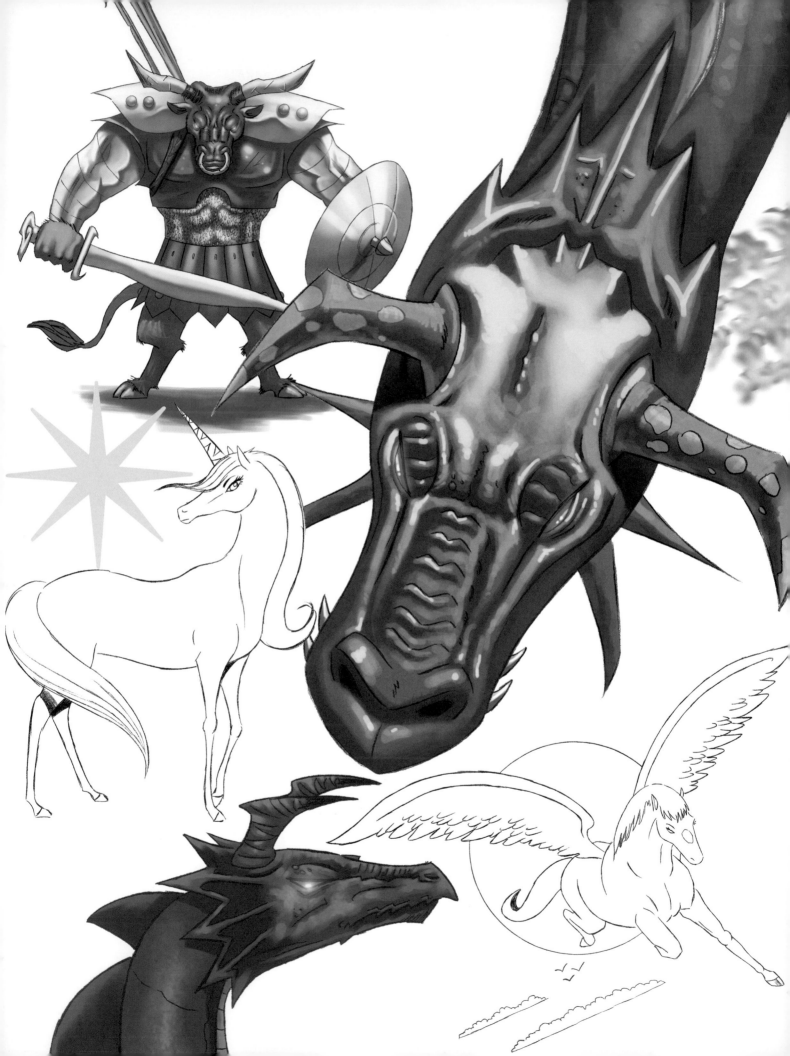

Welcome to The Bestiary

The bestiary is full of darkness and terrifying beings, such as gargoyles and griffins, but there are also unicorns and other noble fantasy creatures. Artists, get out your pencils. Open the gates. Let the creatures of the bestiary run free!

The Dragon

KING OF THE BESTIARY

Legendary and gothic, the dragon is the most powerful beast in the fantasy realm. It possesses a complete arsenal of weapons and special abilities: sheer size and strength, flight, sharp horns and claws, a whip-like tail, razor-sharp teeth and, of course, fire.

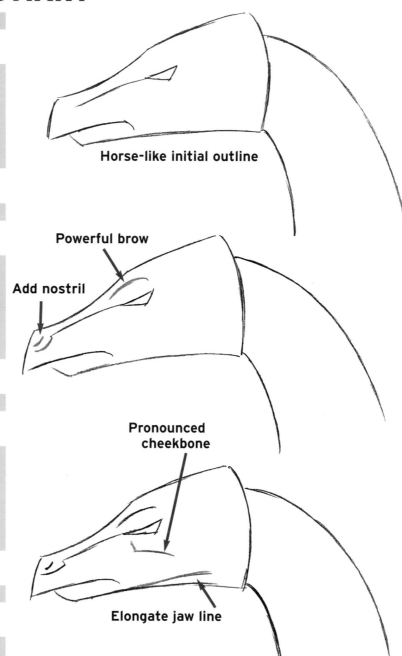

Horse-like initial outline

Powerful brow

Add nostril

Pronounced cheekbone

Elongate jaw line

BASIC DRAGON HEAD

The basic outline of the dragon's head is vaguely reminiscent of a horse's head. But as the steps progress, the outline becomes more angular and severe, until the final result does not resemble a horse in any way.

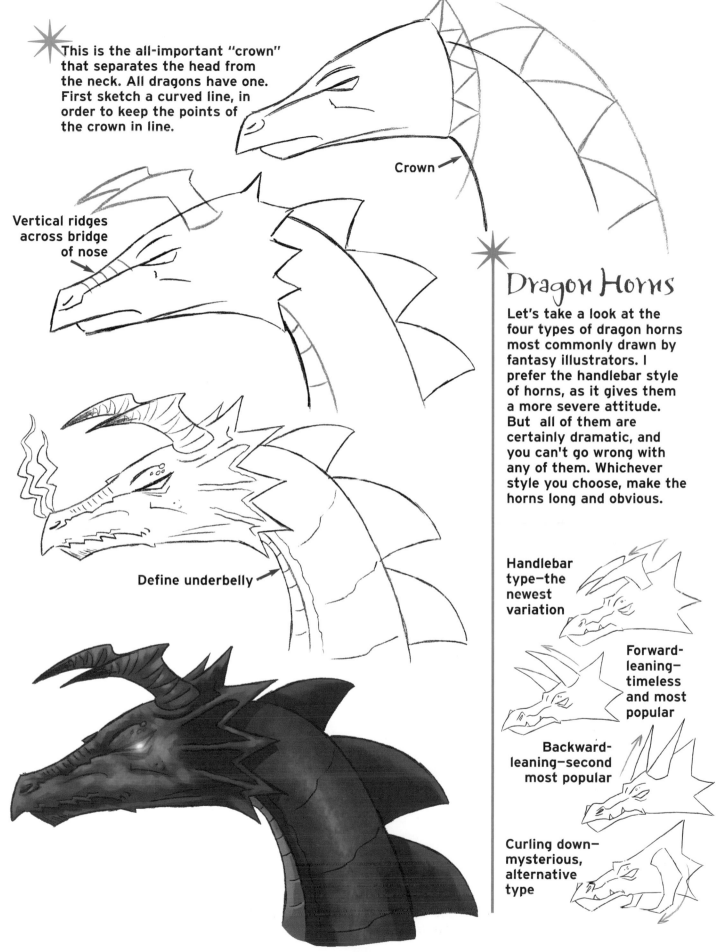

This is the all-important "crown" that separates the head from the neck. All dragons have one. First sketch a curved line, in order to keep the points of the crown in line.

Crown

Vertical ridges across bridge of nose

Define underbelly

Dragon Horns

Let's take a look at the four types of dragon horns most commonly drawn by fantasy illustrators. I prefer the handlebar style of horns, as it gives them a more severe attitude. But all of them are certainly dramatic, and you can't go wrong with any of them. Whichever style you choose, make the horns long and obvious.

Handlebar type—the newest variation

Forward-leaning—timeless and most popular

Backward-leaning—second most popular

Curling down—mysterious, alternative type

87

Smooth and subtle head outline works best

FLAMBOYANT DRAGON HEAD

The closer you get to a dragon's head, the more nuances and details you can see. In addition to the main set of horns, dragons frequently have secondary horns or spikes as well as protruding teeth—ouch!

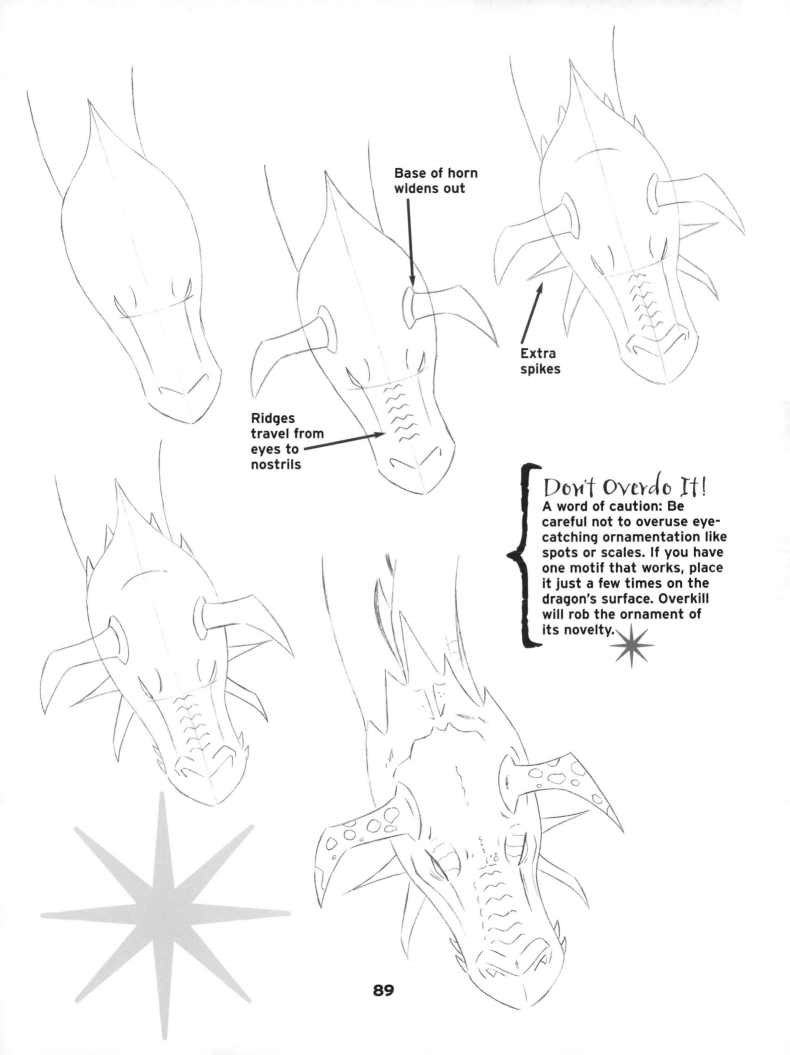

Base of horn widens out

Ridges travel from eyes to nostrils

Extra spikes

Don't Overdo It!
A word of caution: Be careful not to overuse eye-catching ornamentation like spots or scales. If you have one motif that works, place it just a few times on the dragon's surface. Overkill will rob the ornament of its novelty.

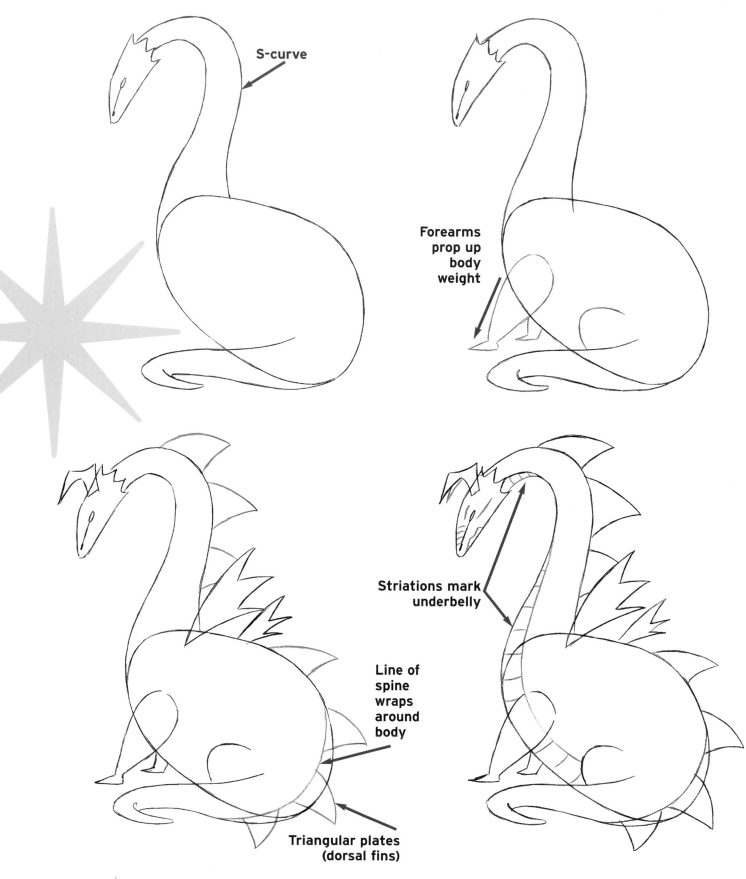

S-curve

Forearms prop up body weight

Striations mark underbelly

Line of spine wraps around body

Triangular plates (dorsal fins)

CLASSIC DRAGON POSE

This proud stance is the classic pose that gives the great beast its stature. Note the long, graduated curve in the neck. Think of the tail as a serpent. See how it wraps around the body? It doesn't lie flat on the ground in a straight line, which would look lifeless.

These tiny wings are just for decoration and are too small for flight.

Overlapping

To create the illusion of depth in a drawing, use the technique of overlapping, in which one part of the figure partially overlaps another that lies behind it. Think of the tail as a winding road. Every time it makes a turn, there's an overlap.

The dragon's neck and tail should be roughly the same length.

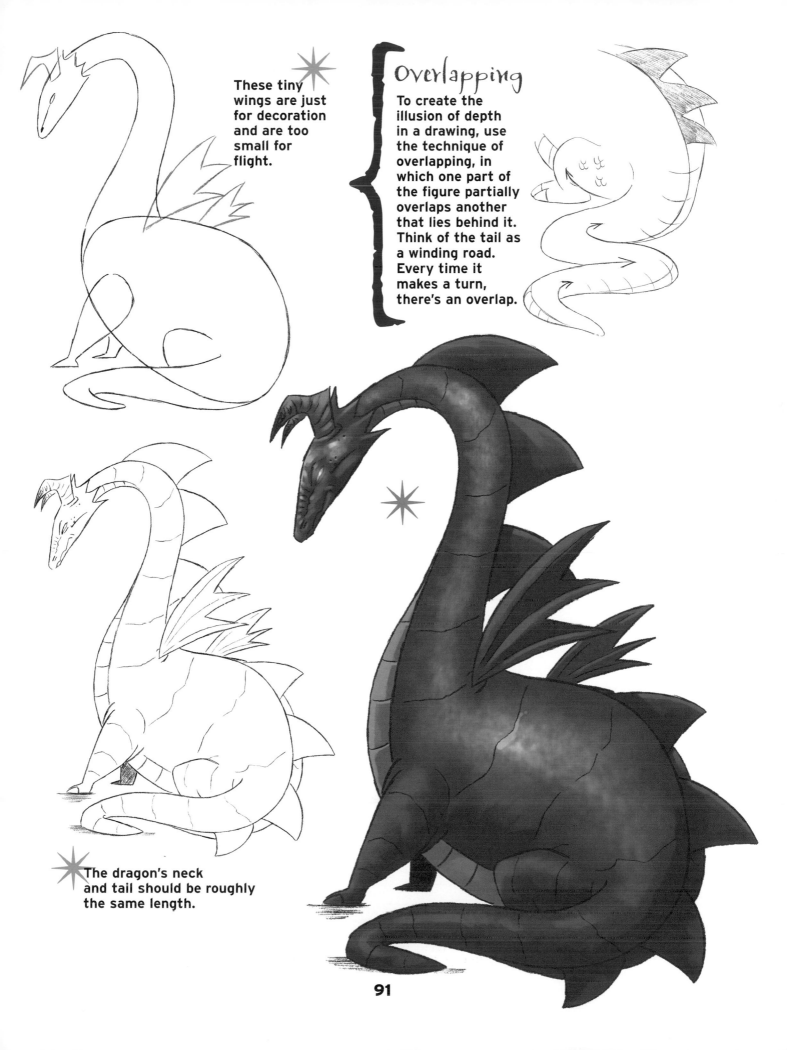

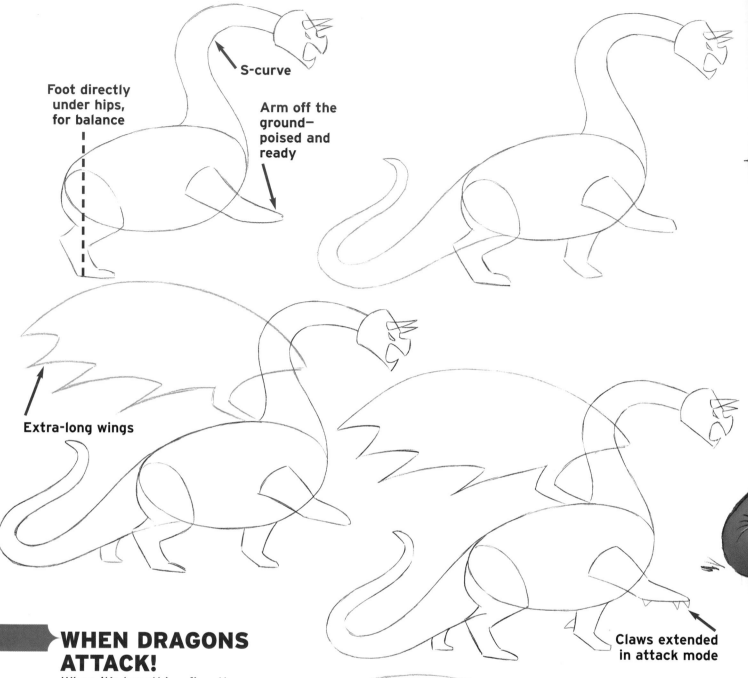

Foot directly under hips, for balance

S-curve

Arm off the ground— poised and ready

Extra-long wings

Claws extended in attack mode

WHEN DRAGONS ATTACK!

When it's breathing fire, the dragon is tense, on edge! Its gut is concave, as it pulls in its stomach to breathe out flames and scorch a village. Give the beast an aggressive, forward-leaning posture when it spews fire. It's the attitude behind the action that brings it to life, not the special effect alone.

You can add a series of rear-facing bones or spikes for the crown of the head

Backward bend in wing-arm lifts wing away from body

Dragon Wings

In all positions and poses, it's a good idea to raise the dragon's wings to avoid obscuring the impressive outline of the body. An exception would be if you wrapped the wings around the body like a mysterious cloak. But most often, the wings have zero to do with the outline of the creature.

Drawing Scales

Draw scales in repeated clumps, not as a solid pattern.

Fins get smaller closer to end of tail

Chest sticks out

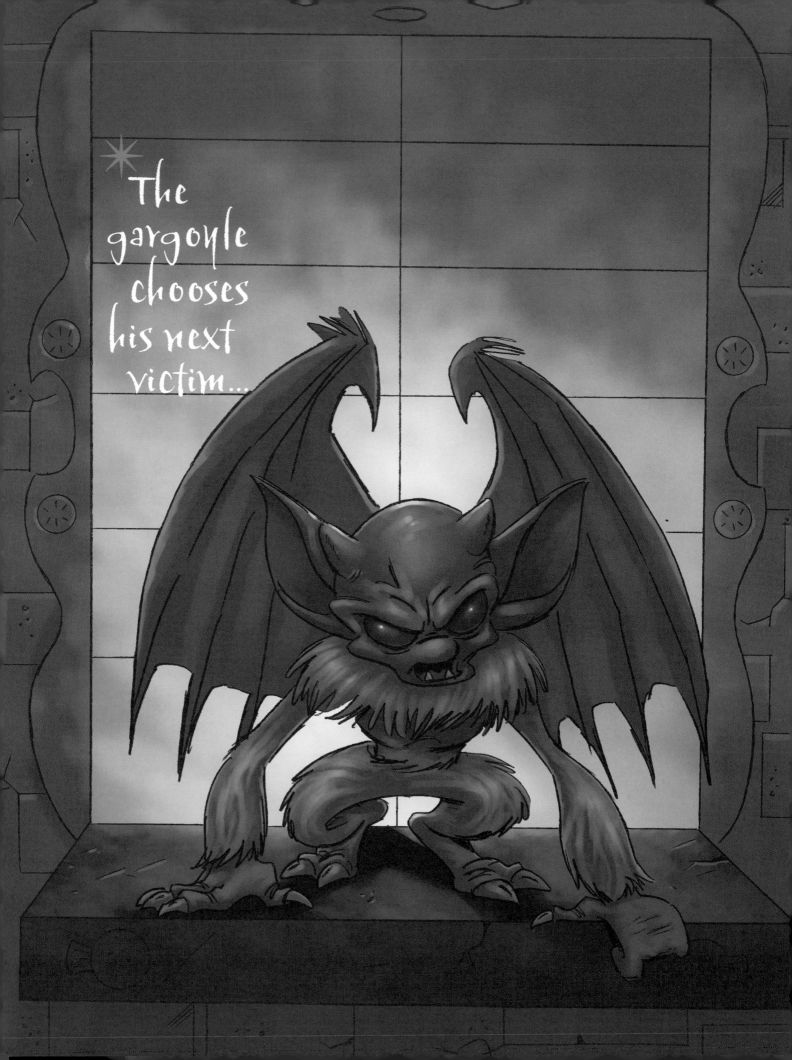

The gargoyle chooses his next victim...

The Gargoyle

Part demon, part bat, the gargoyle is the face of terror. Gargoyles camouflage themselves as decorative statues atop Gothic-style buildings, ready to swoop down and attack unsuspecting victims—mainly humans—below. And so, they are difficult to spot. However, they can sometimes be seen flying, silhouetted against the full moon.

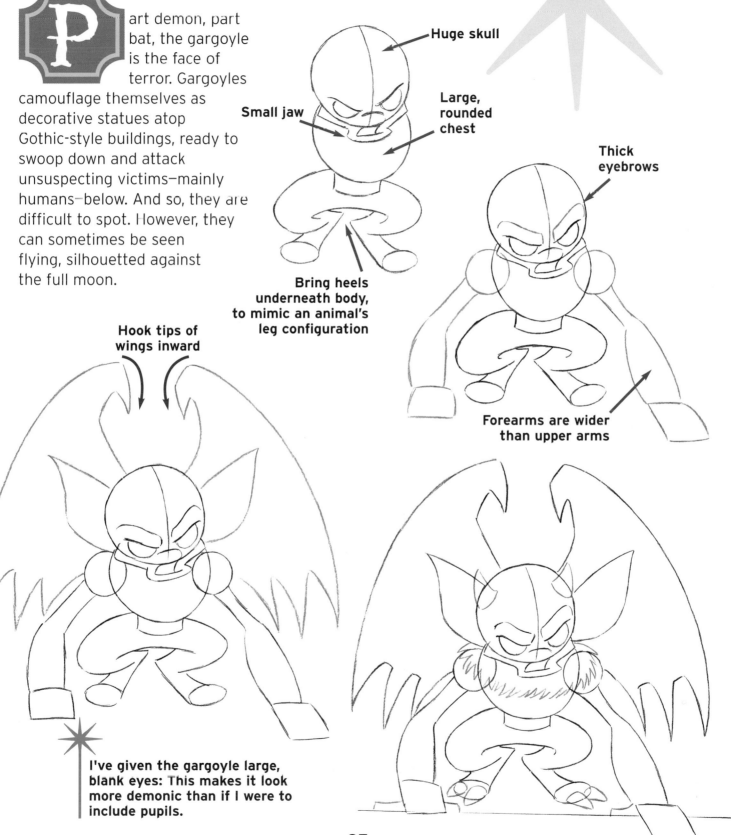

Huge skull

Small jaw

Large, rounded chest

Bring heels underneath body, to mimic an animal's leg configuration

Thick eyebrows

Forearms are wider than upper arms

Hook tips of wings inward

I've given the gargoyle large, blank eyes: This makes it look more demonic than if I were to include pupils.

The Manticore ✳

Super-massive shoulder line →

Human-style arms, shoulders and hands

Knee points out

Arc connects both legs

Small indent just above hooves

Hooves lie flat on ground

No neck

The manticore is a steer with a man's posture and arms. It is always a fighter and a terrible figure to behold. Attire the manticore, a medieval character, in battle-ready armor and weaponry. It is often depicted as leading an army of fighters, sometimes even men, into war. The manticore is an awesome foe.

Shoulder guards flare out

Basic
Construction
of the Head

Draw foundation
outline first
①

Sketch in the
massive jaw
muscles next ②

Add lip
last ③

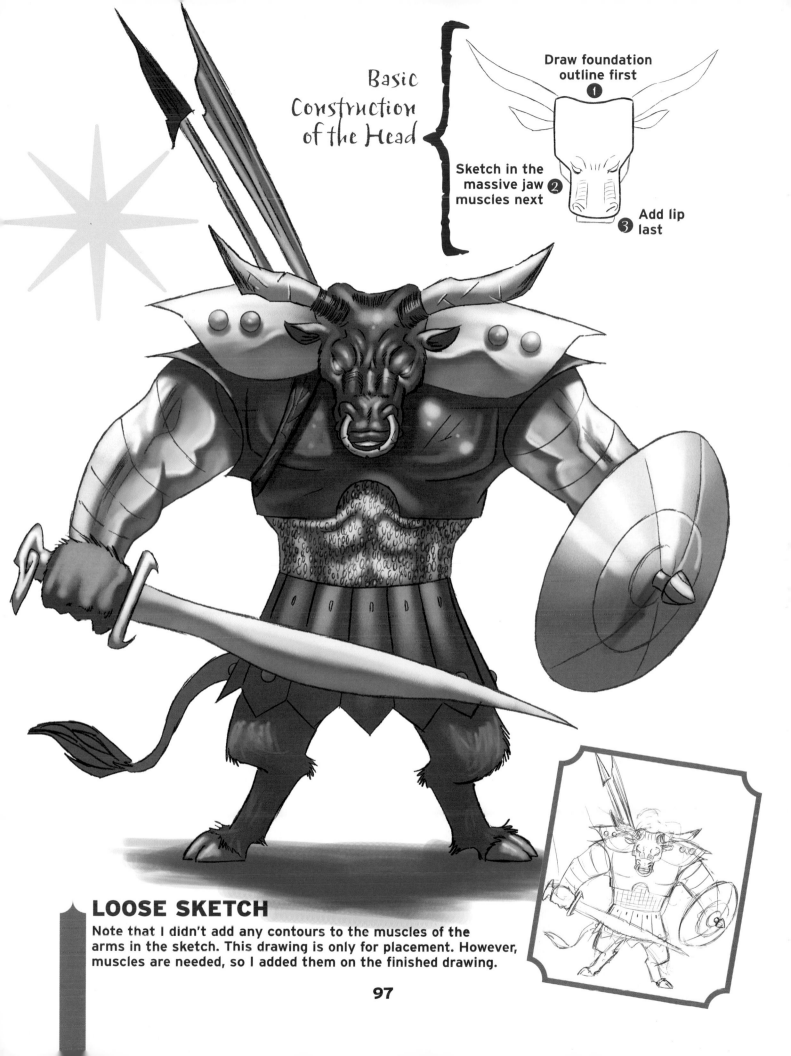

LOOSE SKETCH

Note that I didn't add any contours to the muscles of the arms in the sketch. This drawing is only for placement. However, muscles are needed, so I added them on the finished drawing.

The Griffin

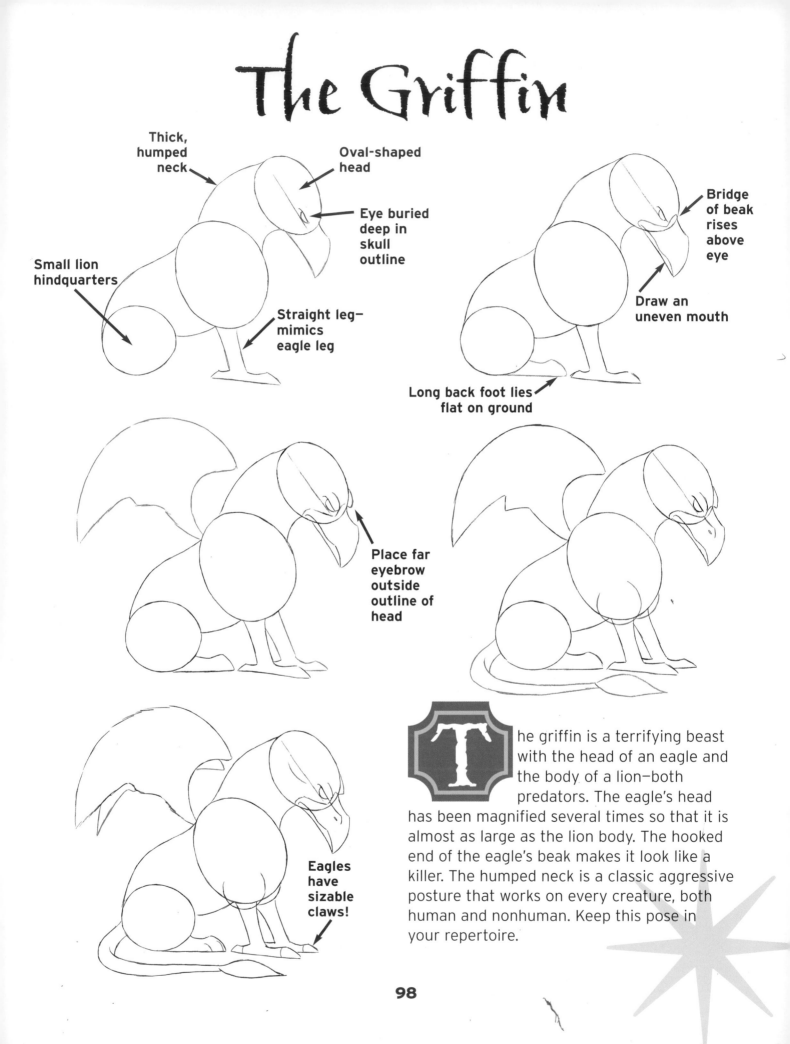

Thick, humped neck

Oval-shaped head

Eye buried deep in skull outline

Small lion hindquarters

Straight leg– mimics eagle leg

Bridge of beak rises above eye

Draw an uneven mouth

Long back foot lies flat on ground

Place far eyebrow outside outline of head

Eagles have sizable claws!

The griffin is a terrifying beast with the head of an eagle and the body of a lion–both predators. The eagle's head has been magnified several times so that it is almost as large as the lion body. The hooked end of the eagle's beak makes it look like a killer. The humped neck is a classic aggressive posture that works on every creature, both human and nonhuman. Keep this pose in your repertoire.

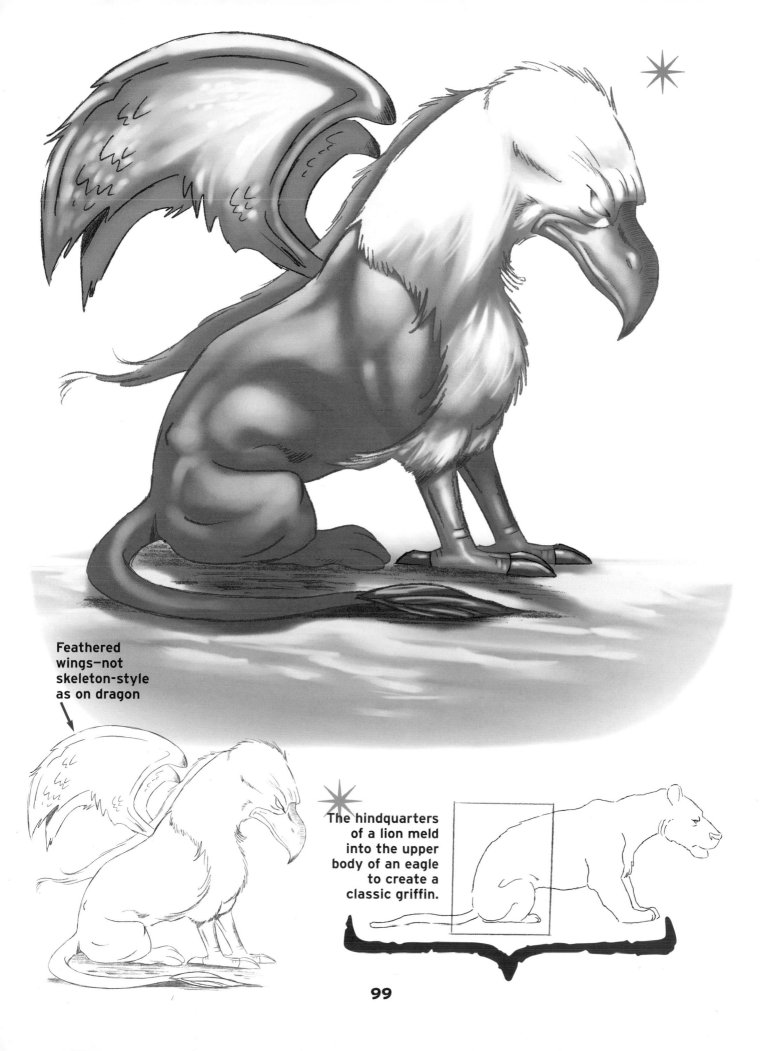

Feathered wings—not skeleton-style as on dragon

The hindquarters of a lion meld into the upper body of an eagle to create a classic griffin.

99

Mystical Tiger

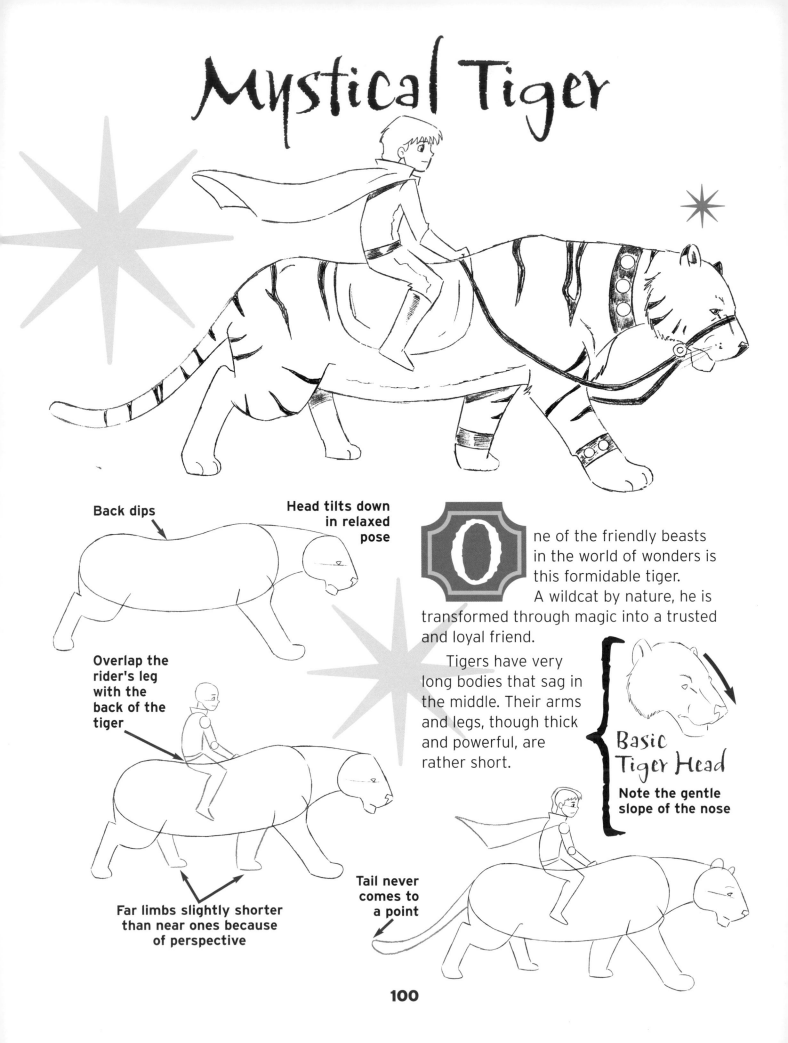

Back dips

Head tilts down in relaxed pose

Overlap the rider's leg with the back of the tiger

Far limbs slightly shorter than near ones because of perspective

Tail never comes to a point

One of the friendly beasts in the world of wonders is this formidable tiger.

A wildcat by nature, he is transformed through magic into a trusted and loyal friend.

Tigers have very long bodies that sag in the middle. Their arms and legs, though thick and powerful, are rather short.

Basic Tiger Head

Note the gentle slope of the nose

Two-Headed Lion

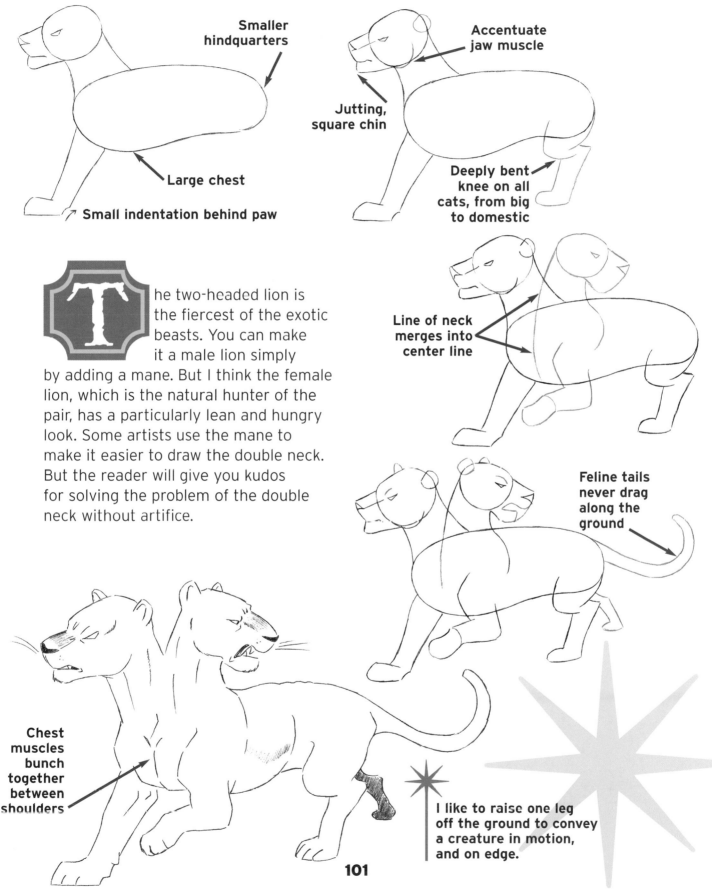

Smaller hindquarters

Large chest

Small indentation behind paw

Accentuate jaw muscle

Jutting, square chin

Deeply bent knee on all cats, from big to domestic

The two-headed lion is the fiercest of the exotic beasts. You can make it a male lion simply by adding a mane. But I think the female lion, which is the natural hunter of the pair, has a particularly lean and hungry look. Some artists use the mane to make it easier to draw the double neck. But the reader will give you kudos for solving the problem of the double neck without artifice.

Line of neck merges into center line

Feline tails never drag along the ground

Chest muscles bunch together between shoulders

I like to raise one leg off the ground to convey a creature in motion, and on edge.

101

Unicorns

lways a favorite, and at one time believed to be a real creature, the unicorn embodies beauty and grace. Paintings from hundreds of years ago show unicorns as ferocious fighting animals with beards dangling from their chins. They were prized for their horns, which were believed to cure diseases. These beasts were not depicted as the graceful creatures we have come to admire today.

THE HEAD

In a close-up of the unicorn, I prefer the three-quarter angle. The side view is a narrower angle of the head, which works well in a full-body pose. But when all you're showing is the head, a fuller angle is more pleasing.

When drawing the three-quarter view, keep two things in mind: First, the far eye is hidden, although we see the "bump out" of its outline. Second, the bridge of the nose becomes a wide, flat surface.

The unicorn's horn can be placed high (A) or low (B) on the forehead.

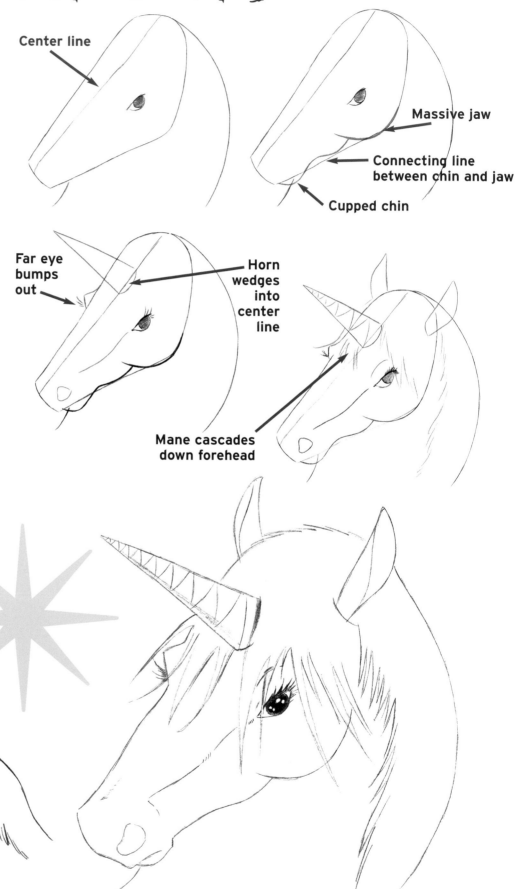

Center line

Massive jaw

Connecting line between chin and jaw

Cupped chin

Far eye bumps out

Horn wedges into center line

Mane cascades down forehead

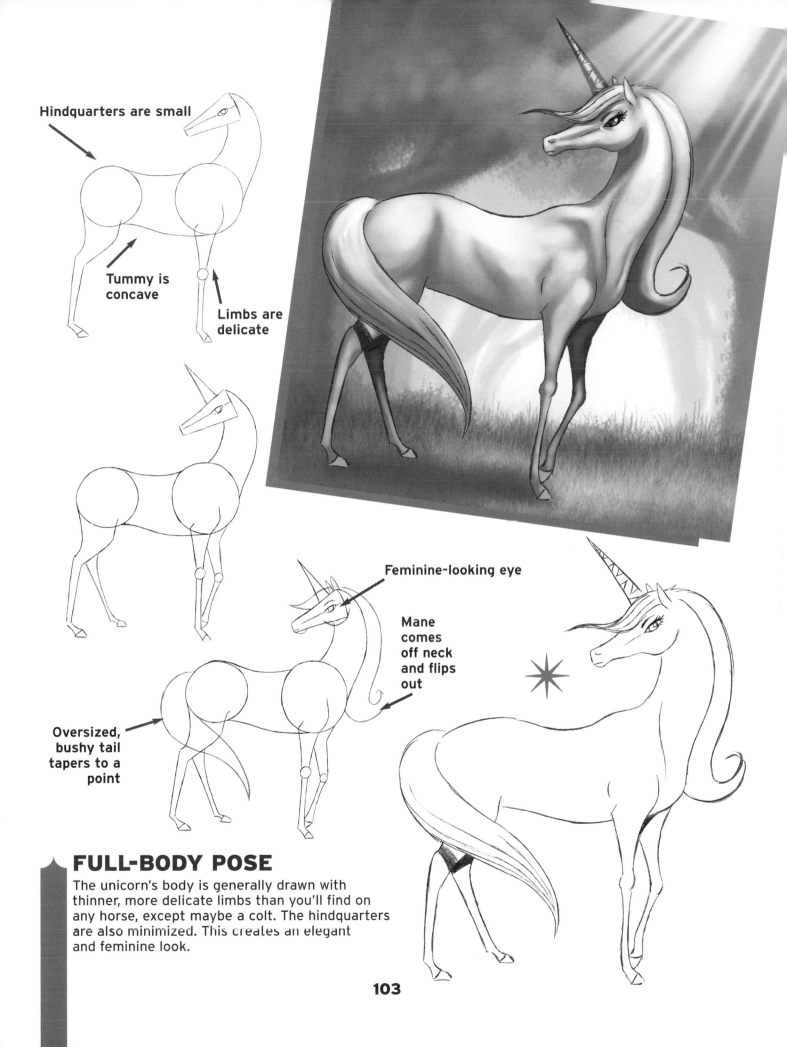

Hindquarters are small

Tummy is concave

Limbs are delicate

Oversized, bushy tail tapers to a point

Feminine-looking eye

Mane comes off neck and flips out

FULL-BODY POSE

The unicorn's body is generally drawn with thinner, more delicate limbs than you'll find on any horse, except maybe a colt. The hindquarters are also minimized. This creates an elegant and feminine look.

103

Pegasus

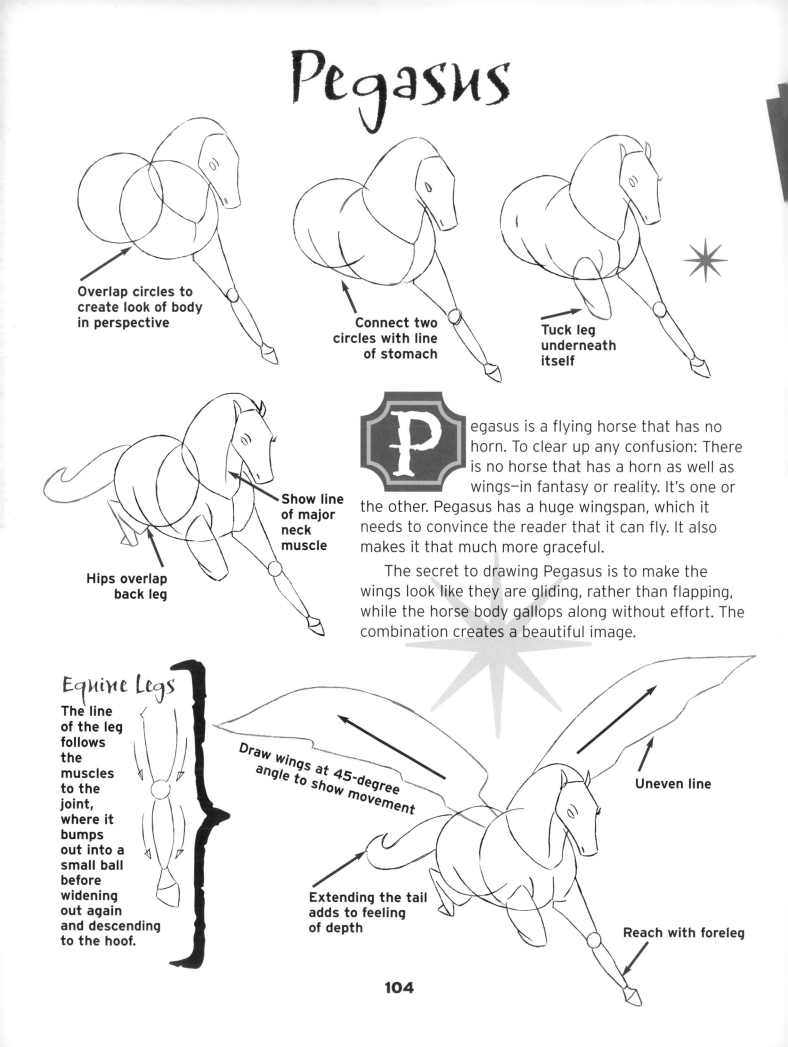

Overlap circles to create look of body in perspective

Connect two circles with line of stomach

Tuck leg underneath itself

Show line of major neck muscle

Hips overlap back leg

Pegasus is a flying horse that has no horn. To clear up any confusion: There is no horse that has a horn as well as wings–in fantasy or reality. It's one or the other. Pegasus has a huge wingspan, which it needs to convince the reader that it can fly. It also makes it that much more graceful.

The secret to drawing Pegasus is to make the wings look like they are gliding, rather than flapping, while the horse body gallops along without effort. The combination creates a beautiful image.

Equine Legs

The line of the leg follows the muscles to the joint, where it bumps out into a small ball before widening out again and descending to the hoof.

Draw wings at 45-degree angle to show movement

Uneven line

Extending the tail adds to feeling of depth

Reach with foreleg

104

Define just the edges of the wings with feathers—don't draw each individual feather.

Since Pegasus is a flier, I like to frame him with either the moon or the sun behind him. Combined with soft clouds, this adds a heavenly element to the image.

Charmed Creature

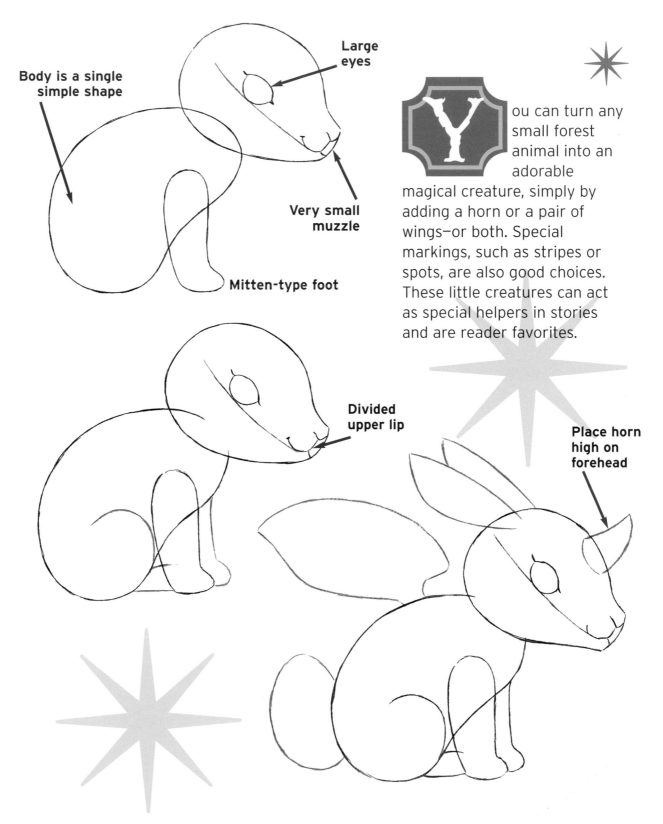

Body is a single simple shape

Large eyes

Very small muzzle

Mitten-type foot

Divided upper lip

Place horn high on forehead

You can turn any small forest animal into an adorable magical creature, simply by adding a horn or a pair of wings—or both. Special markings, such as stripes or spots, are also good choices. These little creatures can act as special helpers in stories and are reader favorites.

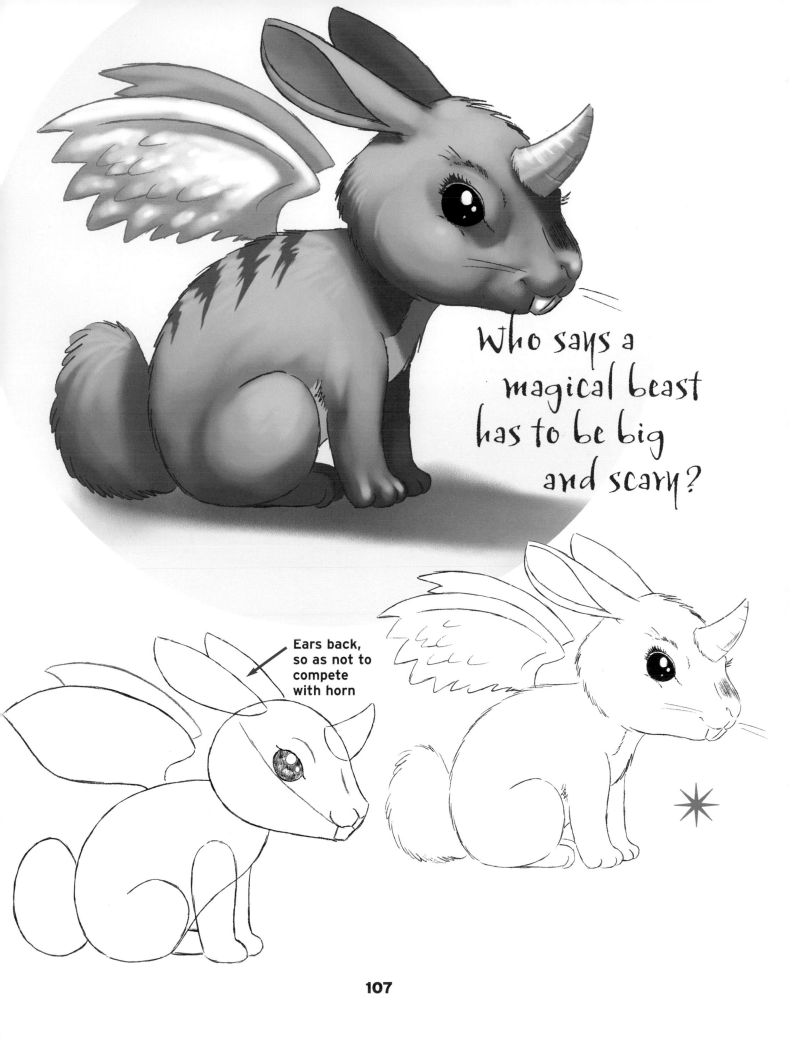

Who says a magical beast has to be big and scary?

Ears back, so as not to compete with horn

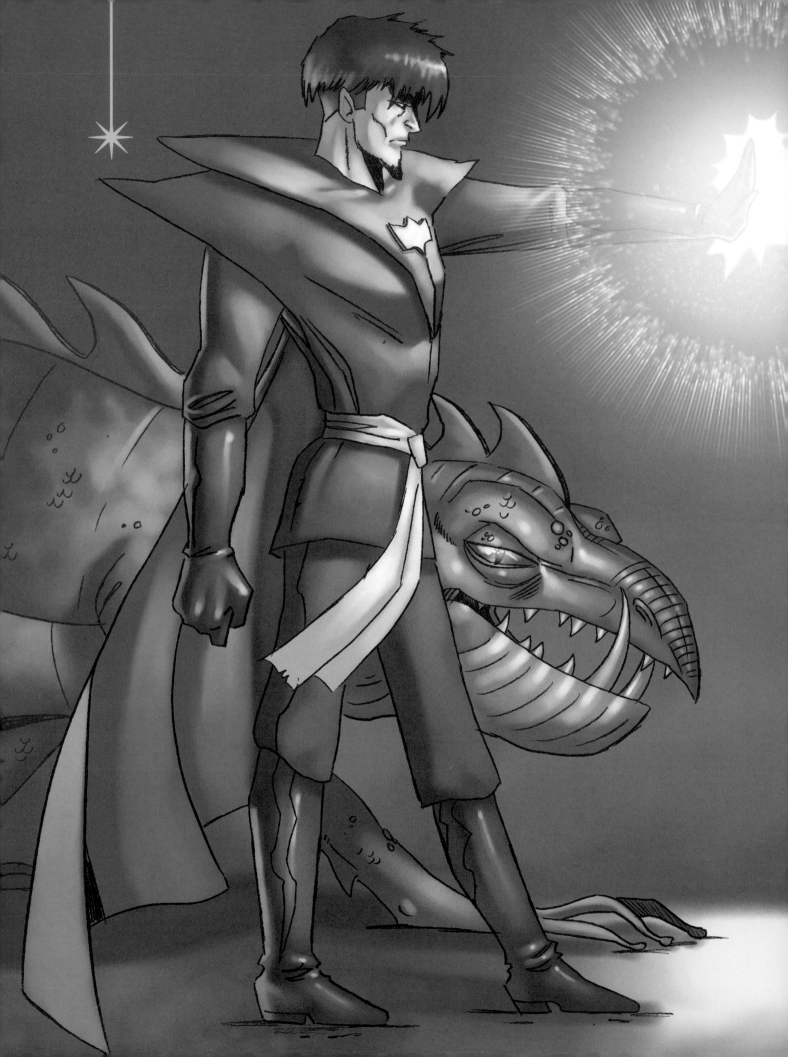

Warlocks
Lords of the Dark Arts

 arlocks, unlike wizards, have a decidedly demonic flair. They draw their powers from the lower forces of nature and the black arts. Unlike witches, many of them retain their youth and good looks. In fact, some of them are lady-killers—if a lady allows herself to get too close.

Warlock Basics

Like many a fictional villain, the warlock is a flashy character and wears a flashy costume to match. He is a shadowy, occultish, fetching figure. As such, he often wears a cape with a high collar, amulets, sideburns and sometimes, but not always, a goatee.

Eyes cut off by eyebrows

Add extra mass here

Tilt head down

Sharp angle of jaw line

DRAWING THE HEAD

The warlock's face is angular and sleek. It has a severe, grave look. His eyes are piercing and intense. Tilt the entire head down as you draw the outline to force the character to look up past his eyelids to see. This is a mysterious look, and one you'll want to capture with this character.

Also, note how the entire face tapers to a point at the chin, creating a super-slenderized face. This translates into a character with no softness—just hard angles.

Keep mouth small and tight

110

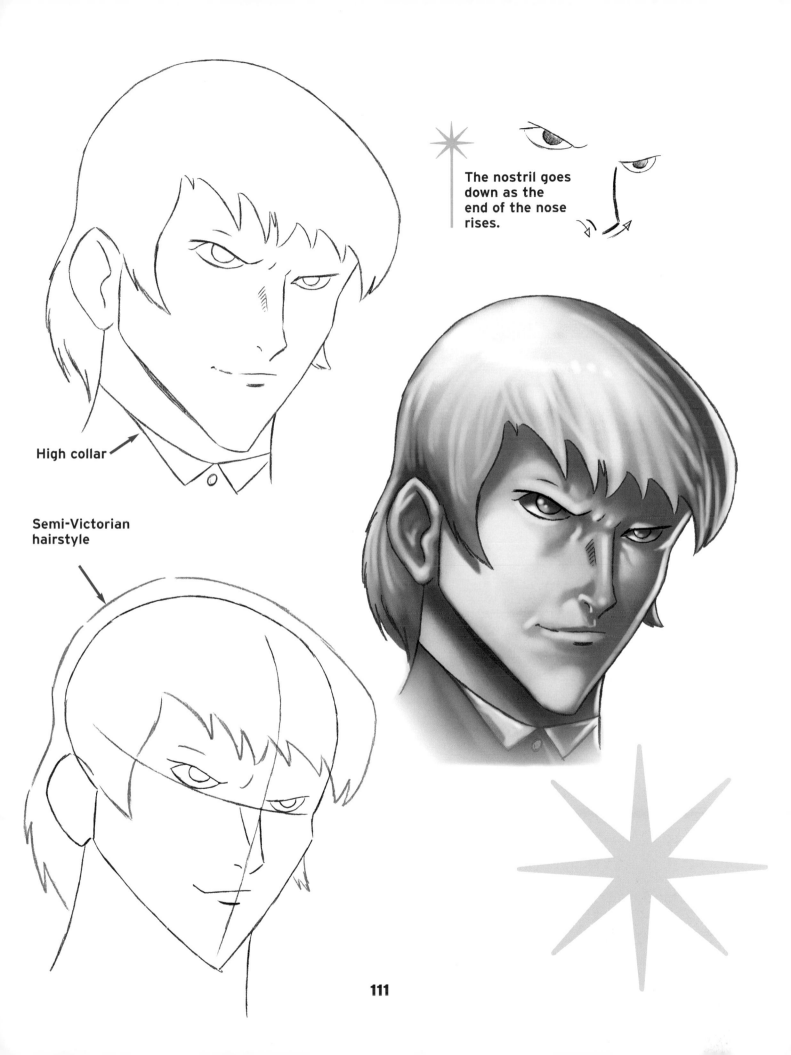

The nostril goes down as the end of the nose rises.

High collar

Semi-Victorian hairstyle

111

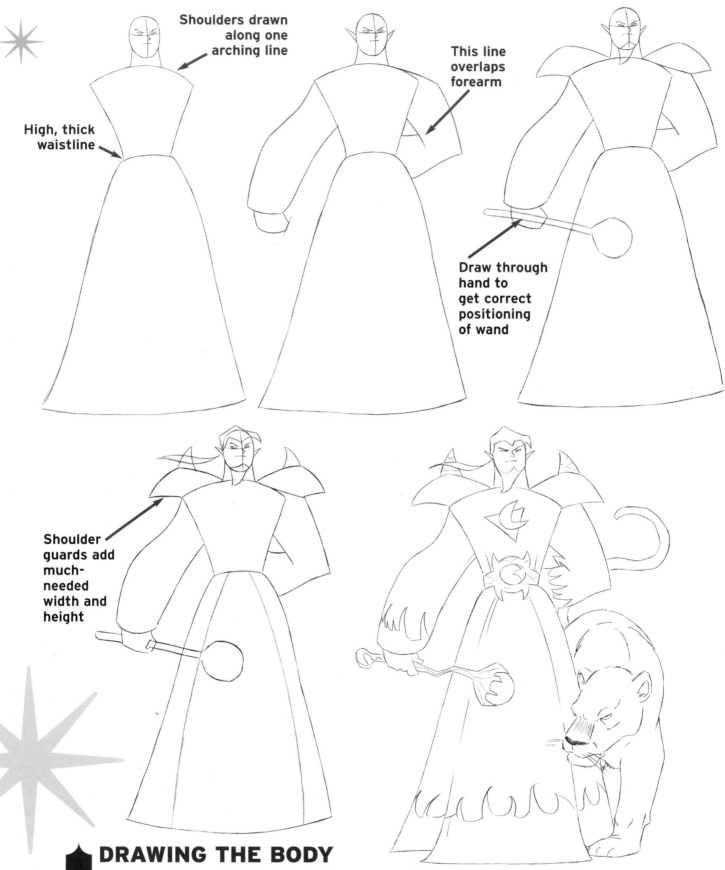

Shoulders drawn along one arching line

High, thick waistline

This line overlaps forearm

Draw through hand to get correct positioning of wand

Shoulder guards add much-needed width and height

DRAWING THE BODY

By clothing the warlock in a large robe, you create a fairly easy-to-draw character that still looks powerful and dramatic. The warlock's robe is more tailored to his impressive build than the wizard's and has a high belt that gathers the material in at the waist. The warlock's robe has no hood, and the robe may also be decorated with emblems and patterns.

Master of the Beasts

The warlock doesn't have small animal friends, such as birds and toads, like the wizard. Instead, he holds dominion by way of spells cast on ordinarily untamed, dangerous beasts, such as big cats. This lets us know right away that he is a dangerous fellow. You can draw the warlock with other creatures, such as giant lizards, dragons, rhinoceroses, dinosaurs or bears, as minions.

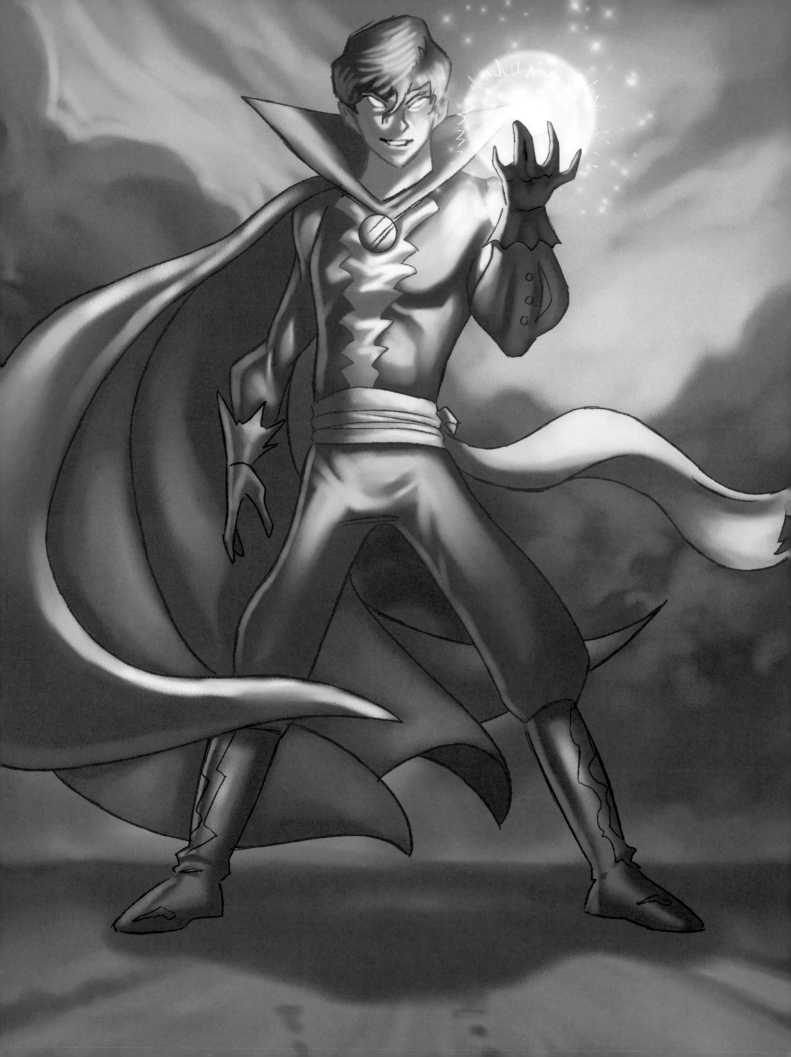

Magical Warlock

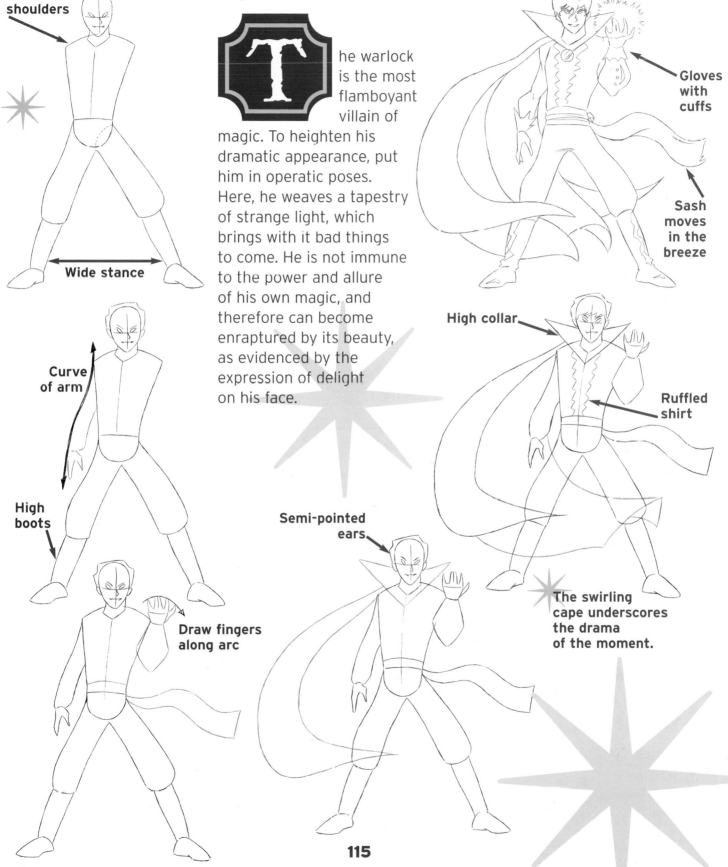

Wide shoulders

Wide stance

The warlock is the most flamboyant villain of magic. To heighten his dramatic appearance, put him in operatic poses. Here, he weaves a tapestry of strange light, which brings with it bad things to come. He is not immune to the power and allure of his own magic, and therefore can become enraptured by its beauty, as evidenced by the expression of delight on his face.

Gloves with cuffs

Sash moves in the breeze

Curve of arm

High boots

Draw fingers along arc

High collar

Ruffled shirt

Semi-pointed ears

The swirling cape underscores the drama of the moment.

115

Brooding Warlock

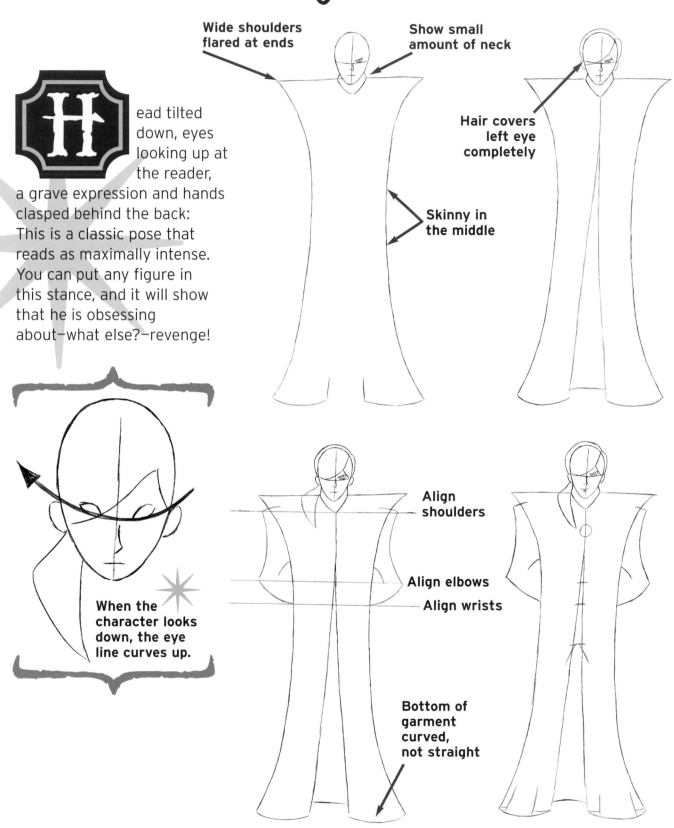

Head tilted down, eyes looking up at the reader, a grave expression and hands clasped behind the back: This is a classic pose that reads as maximally intense. You can put any figure in this stance, and it will show that he is obsessing about—what else?—revenge!

Wide shoulders flared at ends

Show small amount of neck

Hair covers left eye completely

Skinny in the middle

When the character looks down, the eye line curves up.

Align shoulders

Align elbows

Align wrists

Bottom of garment curved, not straight

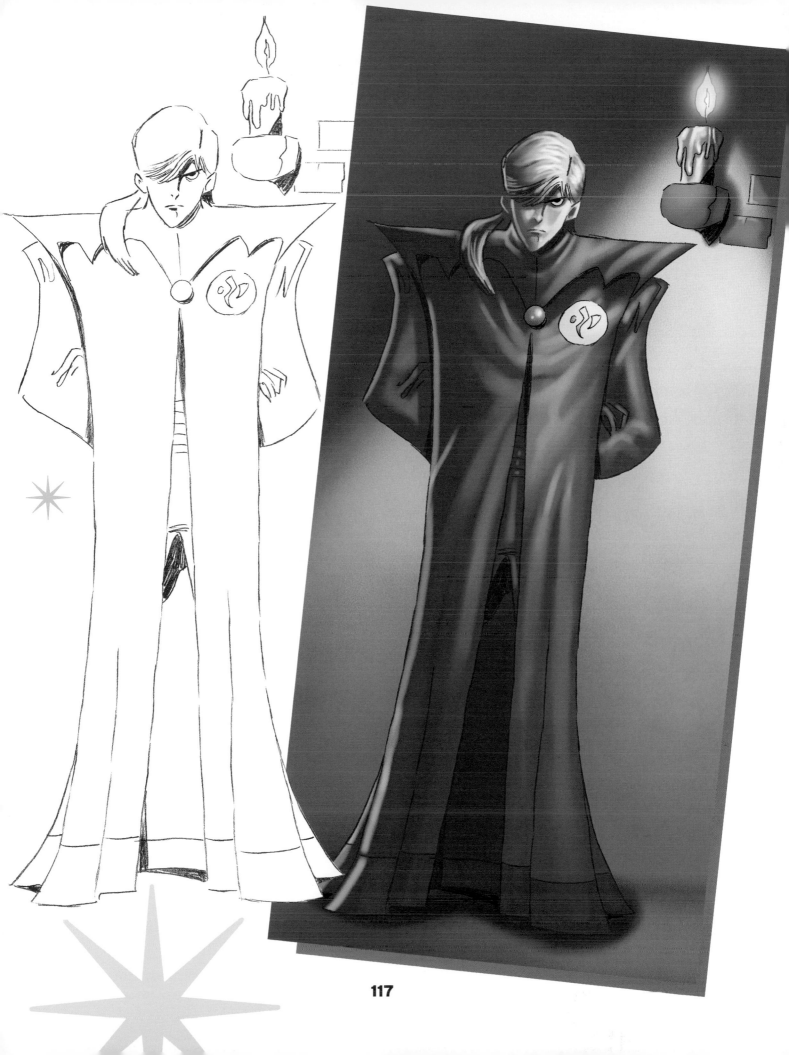

Eerie & Strange

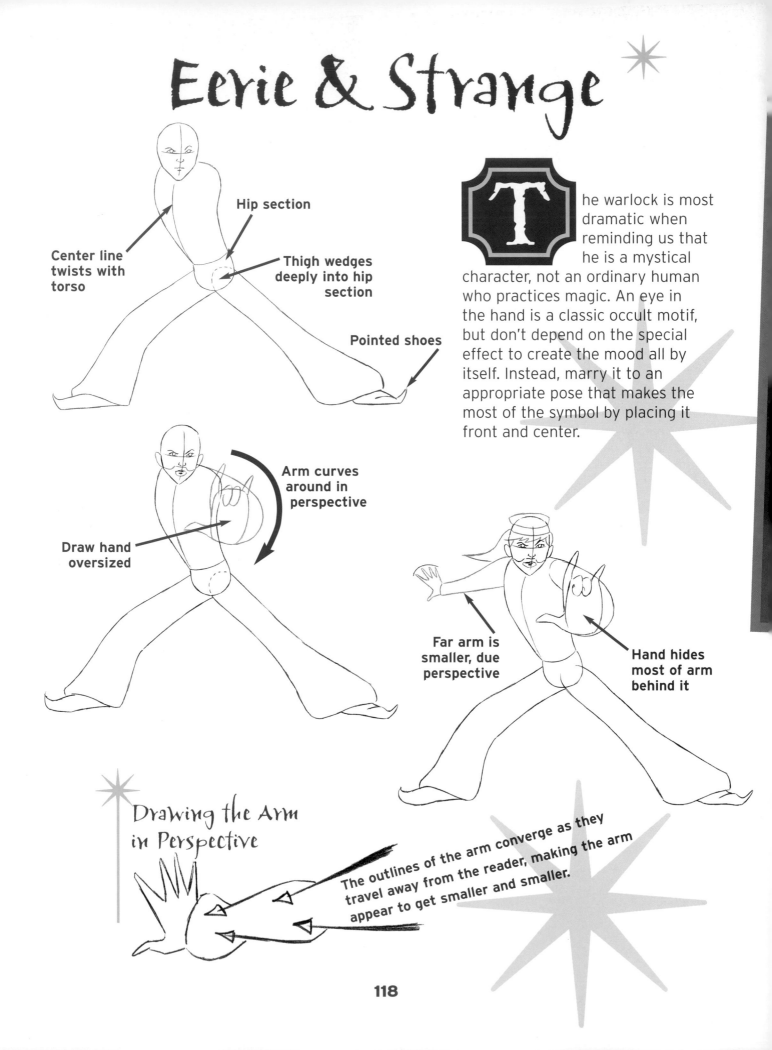

Center line twists with torso

Hip section

Thigh wedges deeply into hip section

Pointed shoes

The warlock is most dramatic when reminding us that he is a mystical character, not an ordinary human who practices magic. An eye in the hand is a classic occult motif, but don't depend on the special effect to create the mood all by itself. Instead, marry it to an appropriate pose that makes the most of the symbol by placing it front and center.

Arm curves around in perspective

Draw hand oversized

Far arm is smaller, due perspective

Hand hides most of arm behind it

Drawing the Arm in Perspective

The outlines of the arm converge as they travel away from the reader, making the arm appear to get smaller and smaller.

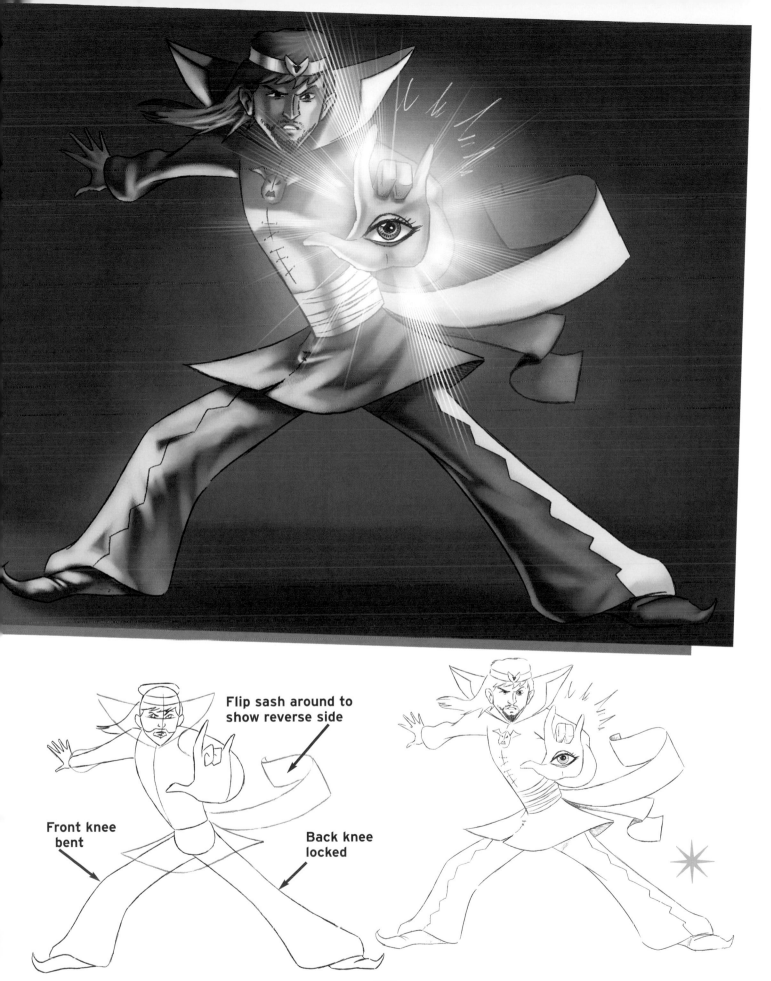

Flip sash around to show reverse side

Front knee bent

Back knee locked

Manga Warlock

Manga, the Japanese style of comics, is so popular that artists of all kinds are incorporating aspects of its style into other genres, including fantasy art. The warlock provides a good subject for the manga style, because he can be portrayed as an evil, androgynous character. Fans of manga will easily recognize this type by his slender, elfin eyes; the soft face and pointy chin; the elongated, upturned nose; and the long hairstyle. He's called a "bishie."

Just like his counterpart in Japanese occult and horror comics, the manga warlock is elegant yet powerful. And he, too, wears an outfit that suggests Victorian themes.

Skullcaps

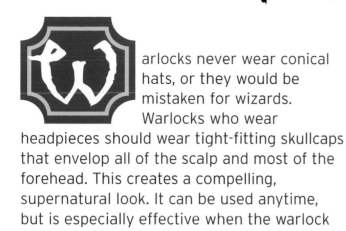

Warlocks never wear conical hats, or they would be mistaken for wizards. Warlocks who wear headpieces should wear tight-fitting skullcaps that envelop all of the scalp and most of the forehead. This creates a compelling, supernatural look. It can be used anytime, but is especially effective when the warlock is performing ritual magic and spells.

Large, rounded skull works well with skullcap

Sunken cheeks

Narrow chin

Clean pencil linework–ready for coloring

Extra-wide cheekbones

LINE WORK VERSUS RENDERING

Sometimes artists become so enamored of color that they color everything, even things that look better in pencil. Pencil drawings often have more subtlety, nuance and ability to communicate than color.

When drawing for color, it's best to use clean lines. Also, avoid excessive pencil shading, as it will compete with the color. But when drawing a purely pencil piece, it's another story. One word of advice: Use a lighter pressure on your pencil to shade than you did to draw the outline of the character.

Finished pencil image, rendered with shading

Master Warlock

H is extra years give him the appearance of wisdom, and bushy eyebrows have a way of making an authority figure out of any character! The bejeweled, form-fitting cap is a better choice than no hat at all, because a head full of wild hair could make him look like a wizard.

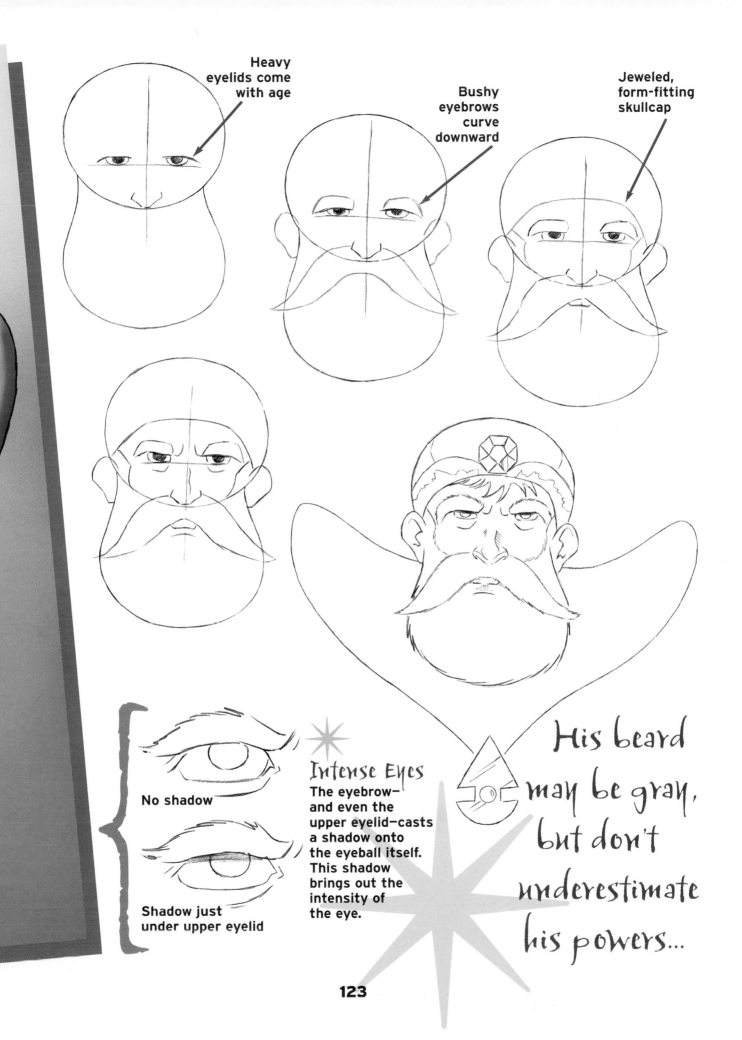

Heavy
eyelids come
with age

Bushy
eyebrows
curve
downward

Jeweled,
form-fitting
skullcap

No shadow

Shadow just
under upper eyelid

Intense Eyes
The eyebrow—
and even the
upper eyelid—casts
a shadow onto
the eyeball itself.
This shadow
brings out the
intensity of
the eye.

His beard
may be gray,
but don't
underestimate
his powers...

123

Masked Warlock

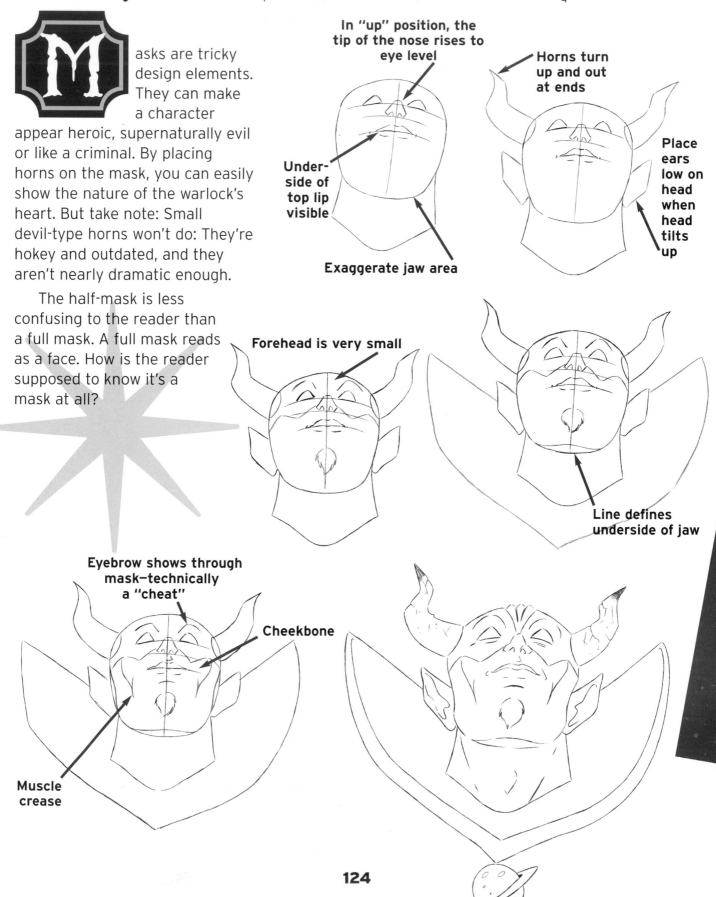

asks are tricky design elements. They can make a character appear heroic, supernaturally evil or like a criminal. By placing horns on the mask, you can easily show the nature of the warlock's heart. But take note: Small devil-type horns won't do: They're hokey and outdated, and they aren't nearly dramatic enough.

The half-mask is less confusing to the reader than a full mask. A full mask reads as a face. How is the reader supposed to know it's a mask at all?

In "up" position, the tip of the nose rises to eye level

Horns turn up and out at ends

Under- side of top lip visible

Place ears low on head when head tilts up

Exaggerate jaw area

Forehead is very small

Line defines underside of jaw

Eyebrow shows through mask—technically a "cheat"

Cheekbone

Muscle crease

The warlock tilts his head up to call forth creatures of darkness.

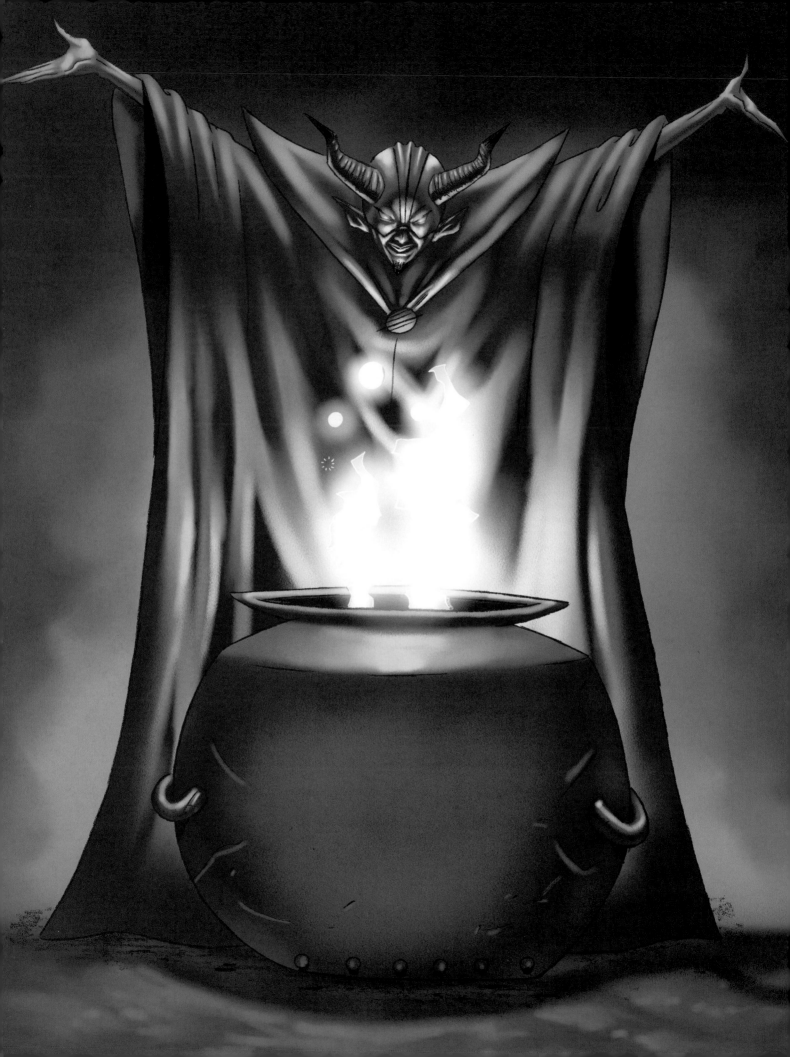

Conjuring Evil

Head dips down into shoulders, hiding neck

Curved vertical line

Never a straight line across the bottom

Skinny arms and bony hands

Interior of sleeve adds depth

ost—but not all—warlocks wear form-fitting outfits, but the ones involved in ritual magic and the conjuring of major evil wear priestly robes that spread out like the wings of a bird. This makes them particularly easy to draw, as it eliminates the structure of the body. However, note how the long lines that make up the robe are subtly curved, not straight. This creates a slinky look and enhances the mysterious atmosphere surrounding the character.

Bubbles & Brew: Alternative Style

Vapors rising from this pot of magical brew can be depicted with either sharply angled smoke (as in the above image) or simplified swirls, as shown here. Either style works, but I prefer the angled type, as it's weirder, and more otherworldly.

127

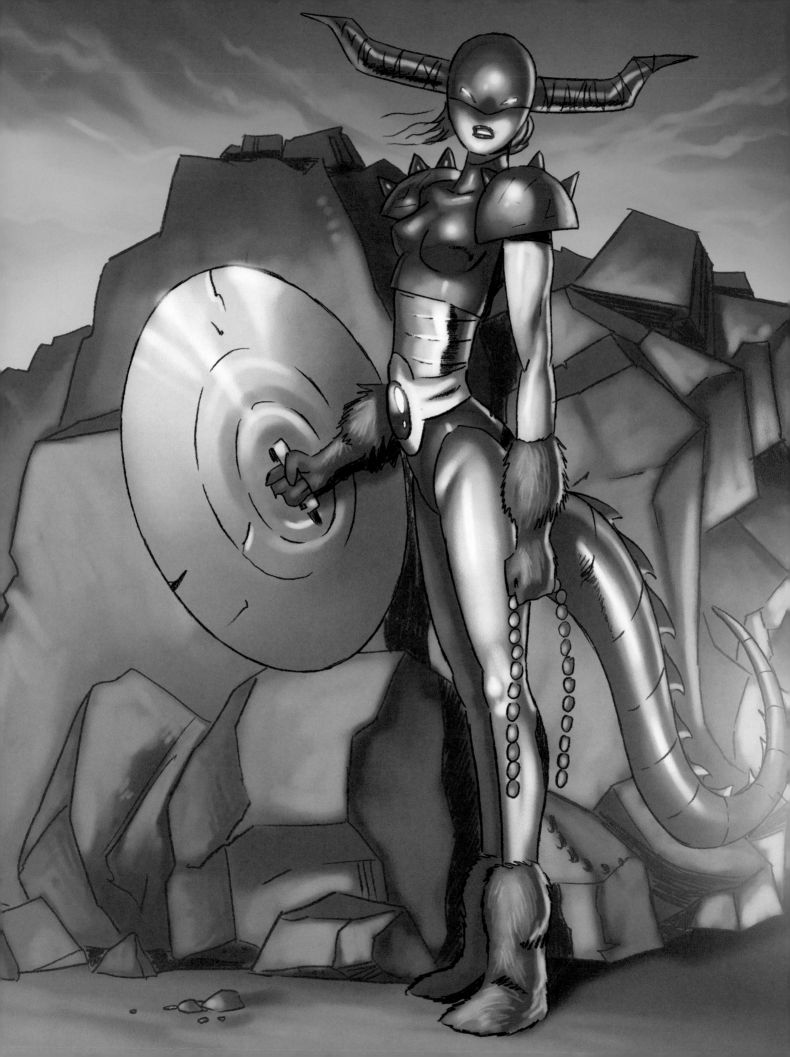

A Gathering of Magical Beings

We round off this book with a variety of popular fantasy characters, including boy vampires, mesmerizing hypnotists and avenging angels. While not as prevalent as wizards, witches and warlocks, they are enduring staples of the genre and are among my personal favorites. You may find some of yours in here, too.

129

The Hypnotist

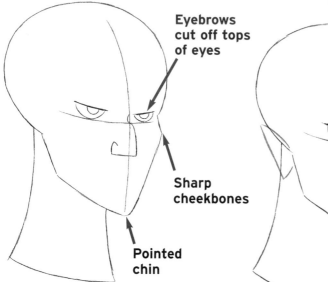

Eyebrows cut off tops of eyes

Sharp cheekbones

Pointed chin

Some hair loosens and falls over eyes

 clean-cut performer dressed in formal suit and bowtie, the hypnotist wears a look of grave concentration. His mouth is taut and small, and the outline of his face is angular and hard, giving him a serious look.

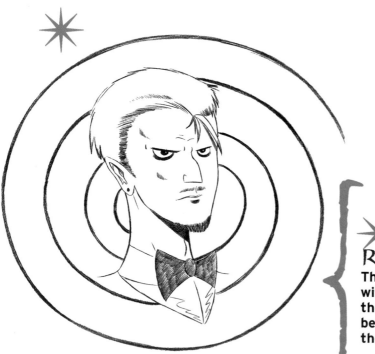

Round and Round
The spinning design is a recurring theme with hypnotist characters. I like to place the character in the middle of the spiral, because the spiral then continually leads the eye back toward the character.

130

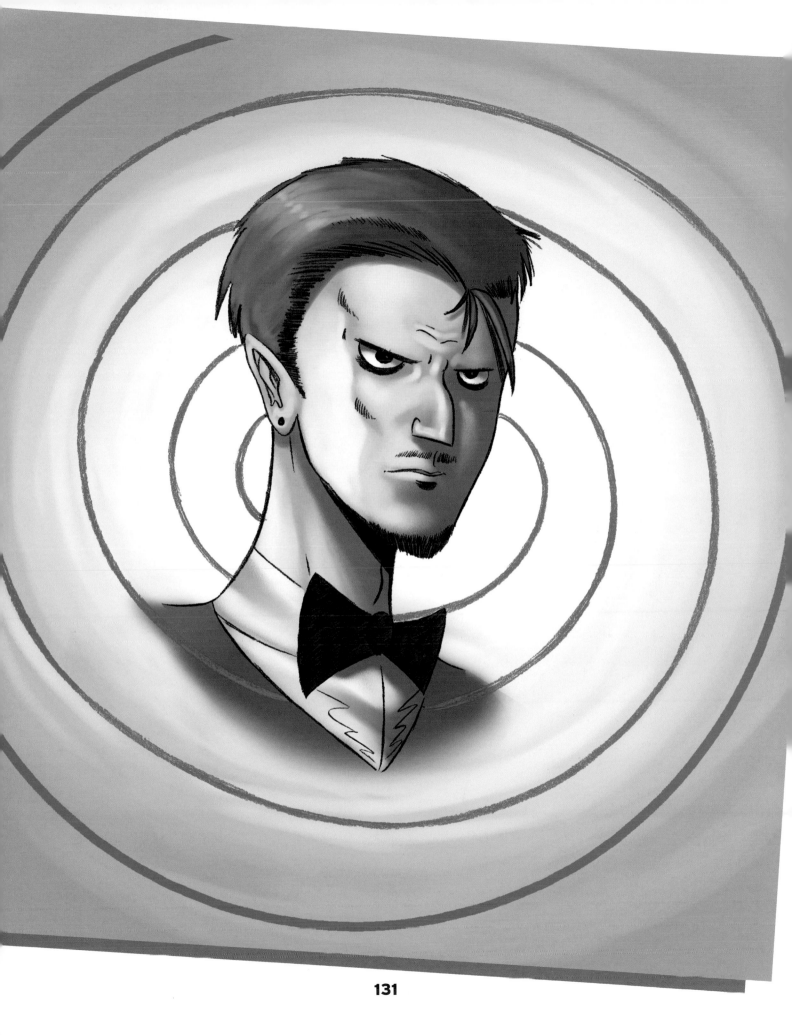

Ancient Astrologer

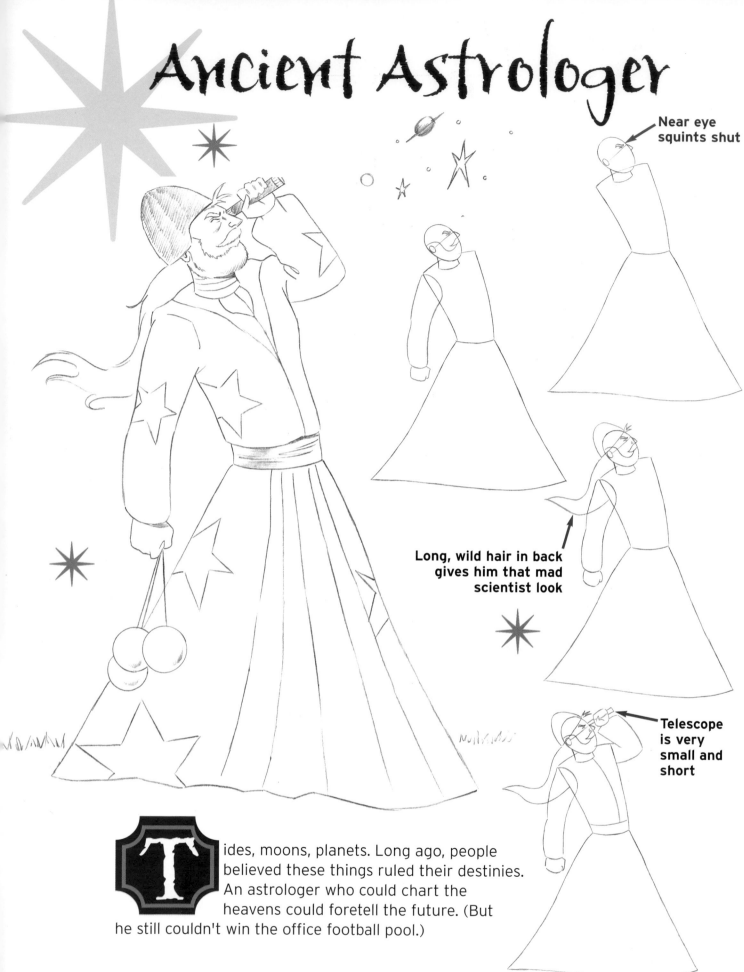

Near eye squints shut

Long, wild hair in back gives him that mad scientist look

Telescope is very small and short

Tides, moons, planets. Long ago, people believed these things ruled their destinies. An astrologer who could chart the heavens could foretell the future. (But he still couldn't win the office football pool.)

The Illusionist

Head tilts down slightly

A re his powers real, or are they merely magic tricks designed to fool the eye? When the illusionist performs his miracles in his traveling shows, he must focus intently. He never takes his own powers for granted.

Back is straight, tense and expectant

Magical powers or clever tricks? An illusionist never reveals his secrets...

Eye line connects to hands

High collar covers bottom portion of face

Pose the illusionist's arms extended in front of his body as he levitates objects.

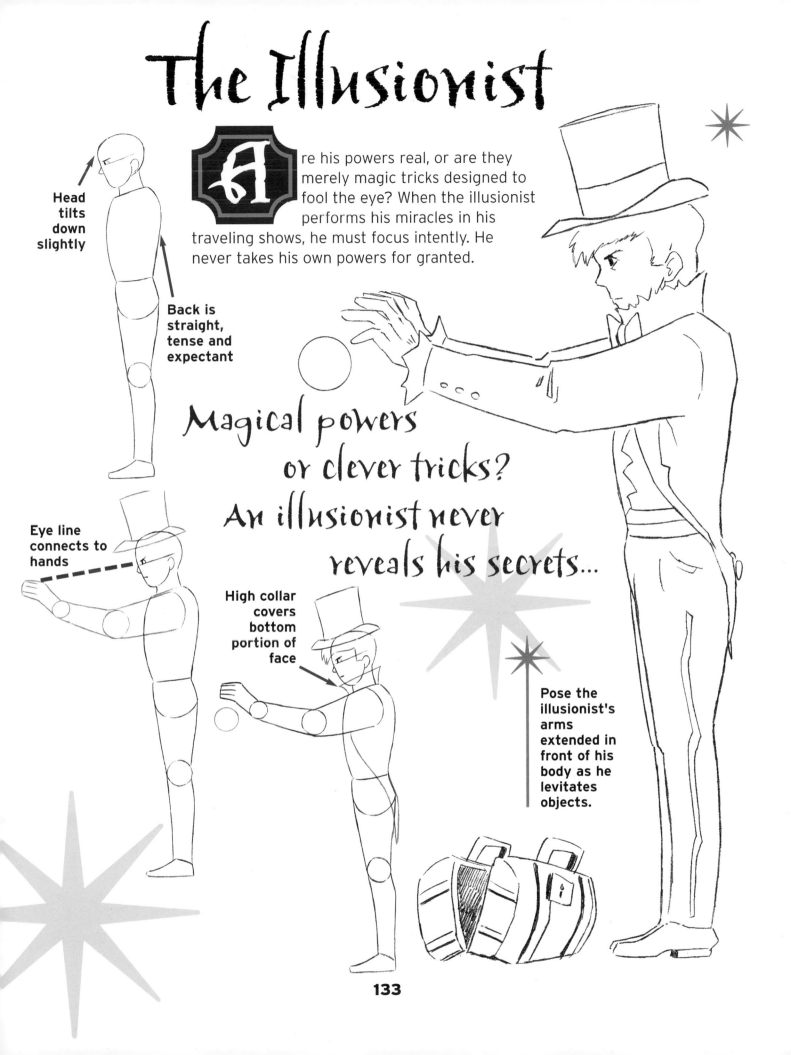

The Oracle

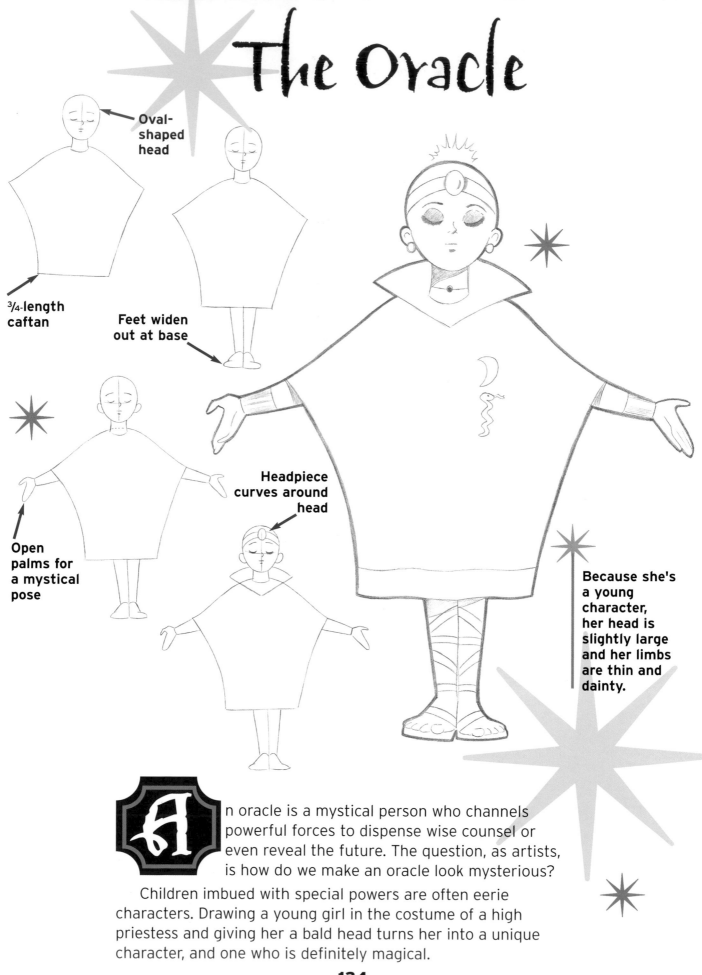

Oval-shaped head

¾-length caftan

Feet widen out at base

Open palms for a mystical pose

Headpiece curves around head

Because she's a young character, her head is slightly large and her limbs are thin and dainty.

An oracle is a mystical person who channels powerful forces to dispense wise counsel or even reveal the future. The question, as artists, is how do we make an oracle look mysterious?

Children imbued with special powers are often eerie characters. Drawing a young girl in the costume of a high priestess and giving her a bald head turns her into a unique character, and one who is definitely magical.

Vampire Boy

Large eyes

Small nose and mouth

T he boy vampire is a sympathetic character. He hasn't yet grown up into a full-fledged vampire menace and might even have some human friends. He's wide-eyed and looks like an affable boy, but he is actually one of the undead.

High collar

Medium-size body

Hide most of body behind cape for a mysterious look

The vampire boy's cape is an important part of his Victorian-influenced costume.

Avenging Angel

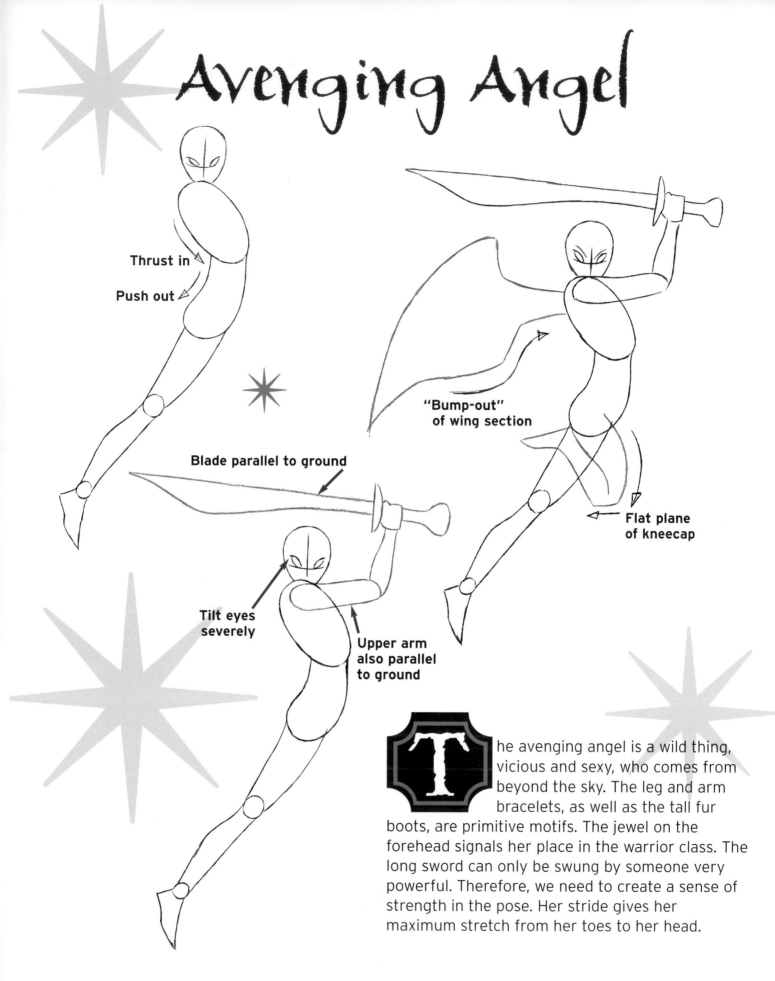

Thrust in

Push out

"Bump-out"
of wing section

Flat plane
of kneecap

Blade parallel to ground

Tilt eyes
severely

Upper arm
also parallel
to ground

The avenging angel is a wild thing, vicious and sexy, who comes from beyond the sky. The leg and arm bracelets, as well as the tall fur boots, are primitive motifs. The jewel on the forehead signals her place in the warrior class. The long sword can only be swung by someone very powerful. Therefore, we need to create a sense of strength in the pose. Her stride gives her maximum stretch from her toes to her head.

Wild hair

LOOSE SKETCH

Notice how she takes a moment to look at you in the midst of her attack. It's as if she has frozen time for a split-second to consider shifting her attack to you, dear reader. This is an artist's way of involving the reader.

When you draw an action pose, try to capture it at the moment of greatest drama. For example, in this drawing, the weight-bearing leg is at its maximum push-off point, with the knee locked and the toes pointed. The other leg is completely bent and tucked under the body. Making a rough sketch helps to capture the drama.

Fighting Mutant

Rib cage

Midsection

Hips

Extra-wide horns

Thick tail cascades gradually off hips; it doesn't stick out

eautiful mutants combine elongated female forms and strange physical adaptations from animals. Mutants based on reptiles are the most common, followed by dinosaurs, birds of prey and big cats.

Lizard appendages, such as this tail, are effective because they don't interfere with the basic character. (Note how the repeated plates get smaller as the tail curls to a point.) Other adaptations include reptilian hands and lower legs and fins. Sometimes, the entire head is lizard, but I believe that creates a repulsive character. The secret to drawing mutants is to make them look weird, but curiously appealing.

Loose Sketch

Chains, spikes, horns and animal skins—she's got more accessories than she has actual clothing to wear.